HIDDEN
HISTORY
of
JACKSON

HIDDEN HISTORY

HISTORY

of

JACKSON

Josh Foreman and Ryan Starrett

THE
History
PRESS

Published by The History Press
Charleston, SC
www.historypress.net

Cover image: Jackson, Mississippi. Stereograph by Elisaeus R. von Seutter, circa 1869,
Mississippi Department of Archives and History.

First published 2018

ISBN 978-1-5402-2812-3

Library of Congress Control Number: 2017958376

This book is dedicated to my parents, Richard Starrett and Mary-Reid Starrett. Thank you for the education you sacrificed to provide me, at school and at home. Thank you for your support, encouragement, guidance and example.
—Ryan

This book is dedicated to my parents, Keith and Elizabeth Foreman, two Jacksonians who have the courage and wisdom to think differently.
—Josh

CONTENTS

CONTENTS

PREFACE

This work is a collection of twenty little-known stories from the history of Jackson. They are by no means exhaustive nor definitive. In fact, many of the chapters are open to alternate interpretations, and every chapter can be expanded and improved. It is our hope that these brief stories spark a more general interest in Jackson's rich history and lead to more scholarly development.

ACKNOWLEDGEMENTS

We would like to thank all those historians, researchers, archivists, teachers, artists and photographers who came before us and paved the way for a project like this. We thank them for allowing us to stand on their shoulders and see the history of Jackson through their own work.

We would like to extend a special thanks to those directly involved in our project—Amanda Irle, the acquisitions editor at The History Press; Ryan Finn, senior editor at The History Press; the Archives of the Catholic Diocese of Jackson; the reference librarians at the University of New Hampshire; the Mississippi Department of Archives and History; the McCain Library and Archives at the University of Southern Mississippi; the Hancock County Historical Society; the Bay St. Louis–Hancock County Library; Charlene Papale, the archivist at St. Joseph Catholic School; Wes Foreman for helping with research from Starkville; Newspapers.com for creating such an amazing research tool; Susan Hertz, Jaed Coffin and Tom Haines for providing feedback and encouragement; John Sigman at the Pearl River Valley Water Supply District; Herb Foreman for providing photos of the Great Flood; those who gave generously of their time to help us understand the history of Jackson, especially Tommy Couch Sr., Derek Singleton, George and Jill Woodliff and John Salter; our sisters, Caitlin Hayden and Caitlin Starrett, who contributed drawings and photographs to the work (as well as countless hours babysitting); and our families, especially our wives and children: Melissa Hubley, Keeland and Genevieve Foreman and Jackie, Joseph Padraic and Penelope Rose O. Starrett. Thank you.

Part I

EARLY JACKSON, 1700s–1830s

WHERE THE CHOCTAW LIVED

The Choctaw was dead, and the funeral rites had begun.

First, his body was placed on an eighteen- to twenty-foot scaffold, in a grove adjacent to his town, and covered with a mantle. Because of his wealth, his mantle was bearskin, and the poles of the scaffold were painted red. Soon his family and friends would arrive to mourn and protect his body.[1] The mourners would weep and wail and question the dead: *Why did you leave us? Did your wife not serve you well? Were you not happy with your children? Did you not have enough corn to eat? Were you afraid of your enemies?* The women in particular would make a great show of grief. Some would have to be carried home after fainting. The men, especially the tougher ones, would hold their vigils at night so that their grief would not be seen by others.[2]

Days, weeks, months later, the flesh would become putrid. Then the undertaker would arrive, with his (sometimes her) long, ceremonial and practical nails. The undertaker would use the nails to pick apart the easily parted flesh and toss it into the fire. He would then gather the bones, wash them and allow the air to purify them. Finally, he would place the bones in a small receptacle and deposit them in the village's bone house. The undertaker, with badges on his thumb, fore and middle fingers (as if his long nails didn't indicate his position), would serve food to the gathered mourners before washing his hands.[3]

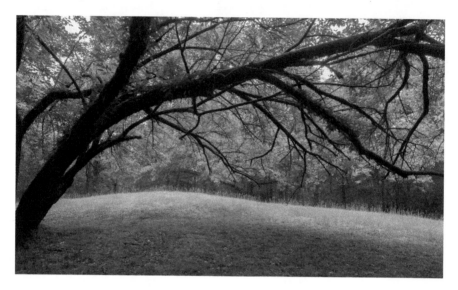

The Boyd Mounds. *Josh Foreman.*

When the charnel house was filled with other Choctaw bones, a ceremony would begin that ended in the construction, or the raising, of a burial mound. On a designated day, the families of the deceased would arrive at the bone house, gather their respective receptacles and march to the mound. They would march in order of seniority, with the wealthier Choctaw dead leading the way.[4] The coffins would be arranged in a pyramid and then covered with dirt.[5] Then the Festival of the Dead would begin.

Village elders and chieftains would be mourned from six months to a year. Children would be mourned for no more than three months. The women would cut their hair. Eventually, the house of mourners would declare their vigil at an end and fulfill their final three days of mourning in which they would wail three times a day, at sunrise, noon and sunset. They would culminate their period of mourning with a one-day feast.[6]

Before there was a Jackson, the Choctaw lived there. Before Louis LeFleur and his European peers arrived, the Choctaw called that land their home. They hunted, farmed, celebrated and fought there. They performed their rites there, building monuments such as the Boyd Mounds, which still stand on the outskirts of the city and hold the remains of dozens of Choctaw.[7]

The Choctaw continued to practice their rites as Europeans moved in. Six Choctaw towns were still building mounds in 1820, including the six Boyd Mounds.[8] But the practice declined as more Europeans moved in and the Choctaw were increasingly and rapidly deprived, by treaty, of their land.

As whites moved into the area now known as Jackson, the Boyd Mounds remained a tangible reminder of who had once called the lands home.

Louis LeFleur, who would come to be known as the father of Jackson, passed the Boyd Mounds many times on his journeys up and down the Natchez Trace. Perhaps he contemplated the meaning of life and death as he reflected on the dead lying in the mounds. Perhaps he focused on the business ventures ahead or behind him. Perhaps he mentally prepared for a feast at his stand with some of his many acquaintances—Silas Dinsmore, Thomas Hinds, Pushmataha, Andrew Jackson and others. So much of the life of the founder of Jackson lies in obscurity, and this has led to much conjecture, inference and mythologizing.

Silas Dinsmore was the federally appointed Choctaw agent at the same time LeFleur traveled the area. Dinsmore certainly would have associated with the Choctaw at the Boyd Site; his Agency House stood only six miles away on the Trace. It was local Choctaw whom he rallied to first arrest future president of the United States Andrew Jackson. One year later, Dinsmore fought under Jackson in one of the nation's most consequential military campaigns.

Pushmataha must have called the inhabitants of the Boyd Site friends. They were his constituents, after all. Pushmataha, chief of the Choctaw at the time of the white influx, entreated his people to cooperate with the newcomers, seek education, make business deals and join whites on the battlefield.[9] Two of his own nieces became some of the first inhabitants of Jackson when they married Louis LeFleur.

William Doak established his stand on the Trace in 1810, not far from the Boyd Site. Like most stands of the Trace, including his contemporary LeFleur's, it served as a gathering place, inn, store, diner and, for Doak, a post office. He was evidently successful, for twelve years later Doak was on the Hinds County tax rolls for owning eighteen slaves.[10] Two hundred years later, there is a debate as to the exact location of Doak's Stand in 1820 because a second stand was erected around 1830. Nevertheless, the general vicinity is known, and as one source wrote, "it was here, in this lonely field, in this obscure corner of Madison County, where the die was cast."[11]

By the time whites moved in, the Choctaw had been crossing the Mississippi River heading west for some time to hunt and, in some cases, settle. Mississippi congressman George Poindexter knew this and planned to use it to his, and his state's, advantage. Poindexter urged Congress to stop

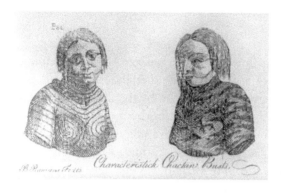

1775 engraving of Choctaw busts. *Library of Congress.*

the free movement of Choctaw into lands west of the Mississippi. In fact, he suggested that they be brought back into Mississippi. Poindexter was hoping to box the Choctaw in, restrict their movements and thereby make them want to sell their lands and go west.[12]

Poindexter revealed his plan to Andrew Jackson, not yet president of the United States, who in turn shared it with another Choctaw agent, John McKee. McKee then warned the Mississippi Choctaw that the U.S. government would soon force their western brethren to return if they did not agree to sell their lands. Pushmataha replied:

> *We wish to remain here, where we have grown up as the herbs of the wood, and do not wish to be transplanted to another soil. Those of our people who are over the Mississippi did not go there with the consent of the nation: they are considered as strangers....I am well acquainted with the country contemplated for us. I have often had my feet bruised there by the rough lands.*[13]

Only a few decades after whites had arrived in the Choctaw Nation, they were seeking to push the Choctaw out. But it would apparently be no easy task convincing the Choctaw to part with their ancestral lands.

In 1820, Congress appropriated $20,000 to arrange a treaty whereby the Choctaw would agree to sell their land and move west. A council between U.S. representatives and Choctaw leaders was set for October 1, 1820.

On September 14, Andrew Jackson left Nashville and eight days later arrived at Doak's Stand. Two days later, agent John McKee and Thomas Hinds arrived. The Choctaw began to appear on October 2. The preliminary

negotiations did not get off to a good start, but after a great ball game on October 9, the two sides sat down and the real talks began.

Despite the fact that the Choctaw failed to present a united front—some were in favor of selling their lands, others accepted the inevitable and still others wished to hold on to what remained of their Mississippi lands—a treaty was finalized after nine days of debate, gift-giving and bribes ($500 "donations" were given to Pushmataha and two other reluctant leaders; smaller amounts totaling $4,675 were given to various others of influence).[14] The Choctaw were to cede 5 million acres in central Mississippi. The relinquished land would eventually form part of nine counties, including Hinds, Madison and Rankin.[15] The sale would clear the way for a new American city to be established on the Pearl River, just south of the Boyd Mounds. In exchange, the Choctaw would receive 13 million acres in the Arkansas Territory.

The Treaty of Doak's Stand was signed on October 18, 1820. Four days later, with his mission accomplished, Andrew Jackson returned to Nashville via the Natchez Trace. One year later, Thomas Hinds, James Patton and William Lattimore chose a spot located in the territory recently ceded by Pushmataha and the Choctaw, at the site of a stand operated by Louis LeFleur, to move the state capital, which would be renamed Jackson.

The Choctaw would eventually be deprived of most of their lands in Mississippi. With Jackson a village still in its infancy, the majority of Choctaw were pushed west, to Oklahoma, on the Trail of Tears. They would leave few traces that Jackson had once been part of their nation. The Boyd Mounds remain, however, a proud reminder of the people who came before.

Over the next two hundred years, Jackson would transform itself from "a muddy little town" into a bona fide state capital; grow as whites moved into the administrative center of the state, some bringing their slaves with them; witness the rapid rise and fall of first the Mystic Confederacy, then the Confederacy, then the Ku Klux Klan; become home to an artist turned mayor; be burned twice in a month and earn the sobriquet "Chimneyville"; become a decade-long home to a Yankee governor; survive several outbreaks of yellow fever; deal with vigilante justice in its streets; become the battlegrounds over a prohibition fight; attempt to become the home of the South's premier university; see the influx of more than one thousand Dutch

pilots and three thousand German POWs, including thirty-five Nazi generals; be home to two enlightened Catholic bishops who would throw their influence behind the civil rights movement; and also become home to segregationist Ross Barnett, civil rights icons Medgar Evers and James Meredith, journalist Bill Minor, music producer Tommy Couch Sr., scores of Sisters of Mercy and Derek Singleton, the first to integrate Jackson's high schools.

James Meredith once claimed, "Mississippi is the center of the universe. The two biggest issues in western Christian civilization are the white-black race issue and the rich-and-poor issue. Mississippi is at the apex of both. And if anybody in the world can solve the problem, it's Mississippi."[16]

If Mississippi is a window into the soul of humanity, then Jackson became what James C. Cobb attributed to the Delta: "[A] mirror within a mirror, capturing not just the South's but the nation's most controversial traits in mercilessly sharp detail."[17] Thus, a study of Jackson, its people and its past will be entertaining as well as instructive.

Louis LeFleur, Folk Hero

Louis LeFleur, the father of Jackson, was a polygamist, a Canadian and a dancer of great renown. He was a small man but strong, thrifty, fabulously rich, happy, hardy and adventurous. He was a war hero, an Indian chief and a cattle rancher. He dressed like Davy Crockett and lived in a log cabin.[18]

Of course, the full truth of those details is debatable. Despite this, all of it has appeared in print in one place or another since Jacksonians began longing, decades after LeFleur's death, to know their very own founding father. The details have appeared here and there in newspaper articles and books—sometimes an adjective is added to the pastiche, sometimes a date. Viewed together, LeFleur becomes a genuine folk hero, tailored to Jackson's particular story.

But who was the man, really? It turns out that historians have painted a more accurate picture of LeFleur through the careful study of records (although their work, some of it unpublished, has never been as widely read as some other, more fanciful accounts). Context from scholars studying the culture of the French traders in pre-statehood Mississippi provides a look at what life was like for men like LeFleur. The more sober portrait that begins to form is one not of a folk hero but rather a larger-than-life character nonetheless.

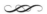

The story of Louis LeFleur was first set down in writing in 1880 in a brief footnote in J.F.H. Claiborne's history of Mississippi. Claiborne claimed to have known LeFleur personally, well enough to recount the man's story from memory some fifty years later. It was Claiborne who first cast LeFleur as a Canadian who loved social functions and dancing. Claiborne related how LeFleur abandoned his birth name for the name "LeFleur" ("the flower" in French), which better reflected his nickname, "the Flower of the Fete."[19] Claiborne's description of LeFleur provides the basis for all further mythologizing of the man.

Louis LeFleur's birthplace is a good place to begin dispelling myths. The majority of accounts of LeFleur's life describe him as a Canadian, but a few point out that he was born not in Canada but in the French colonial city of Mobile in 1762.[20] Ralph and Alberta McBride discovered in 1976 by combing through church records in Mobile that LeFleur was one of a number of children born to a French soldier named Jean Baptiste LeFlau and a Mobile-born Frenchwoman named Marie Jeanne Girard. Louis LeFlau shows up in church records as having been baptized in 1762 and again more than thirty years later alongside the names of several of his children and their two Choctaw mothers.[21]

Establishing that LeFleur was actually born in Mobile, rather than having immigrated to the city in the 1790s, as other accounts have stated, naturally dispels other oft-repeated myths about the man. First, LeFleur was actually born with his name (or a name phonetically similar)—he did not adopt it in his youth because he "danced like a flower in the wind," as one history put it.[22] Second, LeFleur was not Canadian, at least not by birth. Many popular accounts of LeFleur's life have him socializing at French Canada's balls and fetes. He may have spent time in Canada, although no definitive records suggest it; more likely he was born in Mobile and grew up there. Records show, after all, that by his thirties he had fathered several children with his Choctaw partners.

A 1974 feature on LeFleur published in the *Clarion-Ledger* is the source of several embellishments. Not only was LeFleur Canadian, the author wrote, but he was also the "vigorous young favorite of French Canadian society." Not only was he a river trader, but he also "covered his 'sales territory' with diligence and energy." Adjectives were deployed with abandon: "debonair," "graceful," "light on his feet," "well equipped mentally and physically," "strong," "brave" and "extrovert." The article is accompanied by a drawing

How Louis LeFleur likely dressed. *Caitlin Hayden.*

of the man—in it he wears a large fur hat, a tasseled coat and breeches with high socks. He sports a shaggy beard and props his arm on a musket. All in all, the drawing looks similar to Fess Parker's portrayal of Davy Crockett in the 1950s Disney miniseries.

A more accurate likeness of LeFleur is conjured with the help of historian Sophie White. White described in her 2013 book *Wild Frenchmen and Frenchified Indians* the "cross-cultural garb" Frenchmen like LeFleur wore when venturing into Indian territory. Adopting Indian dress allowed Europeans to connect with Indians culturally. And the clothes were simply superior for walking in the woods and traveling along rivers. From the waist down, a Frenchman in Indian territory might appear to have adopted Indian dress completely: moccasins covered the feet, tight-fitting leggings or *mitasses* rose to upper thigh and a breechclout hung between the legs. Above the waist, Frenchmen often wore shirts (although contrary to European fashions the shirts would be loose, untucked and worn as a garment rather than an undergarment); kerchiefs, which were used for caps, headbands or rags; and hooded "capots," a kind of parka originally adopted by Canadian fur traders.[23]

Contrary to the *Clarion-Ledger*'s 1974 depiction, LeFleur was most likely clean-shaven. French frontiersmen did have a penchant for long hair, however.[24]

LeFleur's love life has been the subject of much debate. Early accounts portray the man as a monogamous romantic who, though he married multiple women, only married one at a time. Rebecca Cravat and her sister, Nancy Cravat, nieces of the Choctaw chief Pushmataha, are the two best known of LeFleur's wives. In one account of LeFleur's romance with Rebecca, a writer fully utilizes artistic license. In the account, LeFleur is

walking through the forest when he hears a Choctaw woman singing while she fills a jug with "refreshing water." LeFleur greets her in a "kind voice" and asks for some water. From there, the union is cemented: "Beautiful Rebecca, the Indian maiden, yielded to the gentle persuasions of the lovely Frenchman who was so far away from the people of his own blood. It seemed a degree of fate that he should woo and win this lovely girl."[25]

That LeFleur did some wooing is certain—he fathered more than a dozen children with at least three different women. During the period in the mid-twentieth century when LeFleur's story was repeated several dozen times in Mississippi publications, his romance with Rebecca Cravat, a half-Choctaw "princess," was given the Disney treatment. That he had also married Cravat's sister, Nancy, was explained away by writers such as Martha McBride, LeFleur's great-great-granddaughter, who wrote that LeFleur had only married Nancy after Rebecca had died (other accounts have it the other way around).

A different set of McBrides—Ralph and Alberta, who wrote a more thorough account of LeFleur's life in the 1970s—seem to have been the first researchers to introduce the idea that LeFleur married both Cravat sisters at the same time, around 1790. They point to the fact that no church records exist for LeFleur's marriages and infer that LeFleur was married to the sisters, together, in a Choctaw ceremony.[26] Polygamy was accepted in Choctaw society, and sisters marrying the same man was common enough that the Choctaw had established special rules covering the scenario.[27] LeFleur definitely fathered a child with at least one other woman, a Choctaw named Hoke.[28] At least one source has him marrying a Chickasaw woman as well.[29]

How LeFleur reconciled his romantic predilections with his native faith and culture is unknown (he seemed to have spent time living in coastal Pass Christian after marrying the Cravat sisters, and one can only imagine the gossip the LeFleur family's arrival generated in the community), although he did have the names of at least six of his children recorded at the Catholic church in Mobile.

As for how the man amassed his fortune, the size of that fortune and what he did with it, there are some good sources that provide an accurate idea. The two earliest accounts of LeFleur's life—Claiborne's history and an 1899

book by H.B. Cushman called *History of the Choctaw, Chickasaw and Natchez Indians*—have him earning his fortune at cattle ranching. Cushman wrote that LeFleur was already in Choctaw country in the 1770s, which would support the idea that he grew up in Mobile rather than Canada. Claiborne also mentioned that LeFleur owned a keelboat and earned money transporting goods from the Gulf Coast to Natchez and into Choctaw territory.

LeFleur's path crossed with that of the Mississippi Territory's governor, William C.C. Claiborne, at least once in the early 1800s. LeFleur was tasked by the U.S. government in 1802 with delivering a load of gift goods to the Choctaw Nation. Governor Claiborne wrote letters of safe passage for LeFleur. (Interestingly, it would be Claiborne who would indirectly furnish the layout for the city of Jackson some two decades later.)

LeFleur was certainly a cotton plantation owner, and he owned enough slaves that when he died, he asked they be divided up between his eleven (presumably still living) children. Claiborne put the number of slaves at one hundred.[30]

Of course, there were also the businesses for which he is best known. LeFleur operated celebrated "stands" along the Natchez Trace: LeFleur's Bluff on the Pearl River at the present-day site of Jackson and French Camp, some eighty miles north of Jackson. The Pearl River stand was famously built atop a high bluff on the west side of the river. When state leaders were commissioned to find a place for a capital city in 1821, they eventually settled on LeFleur's Bluff, writing that the stand had everything needed for a city: "elevated position, pure water, wholesome air, fertile soil, useful timber, a navigable stream, and the advantage of public roads."[31]

The stands of frontier Mississippi were scarce, vital waypoints for travelers making their way through Choctaw and Chickasaw territory. They offered a place to sleep in addition to food and drink. Food was usually sourced from an adjoining farm or procured from the woods or—likely in LeFleur's case—the Pearl River. One stand advertised some of its wares in 1815: coffee, sugar, biscuits, bacon and whiskey. Corn was commonly eaten, including ground hominy, which was carried for emergency rations (and should be familiar to lovers of grits).[32]

The *Clarion-Ledger* provided an artist's sketch in 1936 of what LeFleur's home might have looked like.[33] In modern parlance, it could be described as a "micro home." It is a few hundred square feet with two windows, a door and a chimney. While LeFleur's original home might have been modest, the fact that his stand was well known along the Trace means that his operation was probably larger.[34]

The Pearl River near where Louis LeFleur established his trading post. *Josh Foreman*.

When LeFleur died in 1833, he identified himself first as "of the Choctaw Nation," then as of the State of Mississippi. He lived among the Choctaw when there were few other Europeans around, married Choctaw women and had Choctaw children. According to the earliest narratives of his life, he spoke Choctaw and was beloved by the Choctaw people. That he became a "chief" of the Choctaw, as one early source claimed, does not seem borne out by evidence.

LeFleur does seem to have been a bona fide war hero, however, serving under the overall command of General Andrew Jackson in a Choctaw regiment, alongside Pushmataha, in the War of 1812. Although few details of his activities in the war exist, he was promoted to the rank of major for "valor in the field."[35] He continued to serve with American forces for the next three years, leading a company into Alabama during the Creek War in 1814 and serving under Andrew Jackson in the Pensacola Campaign of 1814 and 1815, which saw a force of four thousand Choctaw and Americans rout an army made up of refugee Creek Indians, runaway black slaves and British soldiers.[36]

Thomas Hinds, who would go on to eventually help choose LeFleur's Bluff as the site for the city of Jackson, was a cavalry commander during the Pensacola Campaign, and it's likely LeFleur met him then. It's also likely that LeFleur knew and respected Andrew Jackson, who had stayed at his stand at French Camp during the War of 1812; LeFleur named his son, born in 1815, Jackson.[37]

A sober examination of Louis LeFleur's life proves the old adage that truth is stranger than fiction. He may not have been the toast of Canadian society or a famed dancer, but he was certainly an incredible character. During his lifetime, he lived under as many as six national governments, provided food and shelter for travelers on the Mississippi frontier, fought, loved, led and earned. He seemed to have met nearly every figure important to the history of early Mississippi and to have been present at pivotal moments. He is not a folk hero, but he's a fitting father for Jackson nonetheless.

SILAS DINSMORE, WHO EARNED JACKSON'S IRE

Silas Dinsmore was a shiftless, undependable, sniveling bureaucrat…or he was a hardworking, respectable, self-made and patriotic man. It depended

on who was queried. Regardless, Dinsmore would probably be a forgotten man had it not been for an encounter, a feud, with a far more powerful and eventually famous personage: Andrew Jackson.

Dinsmore was a recent graduate of Dartmouth College in New Hampshire when he decided to embark on a career in the Indian service. He was assigned to work in the Cherokee amphitheater but quickly shifted over to the Choctaw Nation in 1802. He arrived several months late for his assignment because he was recovering from wounds received in a duel.[38] He quickly adapted to his new surroundings and was evidently respected by the Choctaw people. However, U.S. Secretary of War William Eustis felt the need to threaten Dinsmore with removal should he fail to keep himself inside the Choctaw Nation.[39] Clearly, Agent Dinsmore had a problem with staying on task.

He also had a problem alienating authority. He was, according to historian Bette B. Tilly, a "determined, stubborn individual who feared neither governors nor militia generals."[40] His arrest of Louisiana governor Claiborne's personal emissary, while on official state business to the agency, gives credence to Tilly's character sketch.

In 1811, a number of wealthy planters came to Dinsmore and requested that he crack down on runaway slaves who were fleeing to the Choctaw Nation.[41] (Although he owned one hundred slaves at his death, it would be an inference to say that Louis LeFleur was one of these planters.) Many of these slaves had arrived in Mississippi via the Natchez Trace, the federal highway that cut through the Choctaw territory. The Choctaw themselves as a whole did not approve of slavery, but neither did they want runaway slaves inside their borders. Thus, all along the Trace, signs were posted, by whites and Choctaw, warning slaves that should they escape, they would be caught and returned to their masters.[42] Dinsmore acquiesced and began to rigidly enforce an 1802 federal law that required those traveling the Trace through Indian territory to present a passport when called on. Furthermore, the law required any white traveling with a black slave to produce proof of ownership. Dinsmore's residence, the Choctaw Agency House, sat right beside the Trace. Therefore, every traveler of the Trace would likely have had to pass right under his nose.

Andrew Jackson traveled down the Trace from Nashville to Natchez the year of Dinsmore's crackdown. When he arrived at the agent's house, he saw a number of whites being detained because they could not produce their passports. The future president of the United States exploded at the indignity. He questioned their own freedom and manhood and urged them

to ignore Dinsmore and be on their way. Jackson led by example, refusing to produce his passport and continuing on his way with vitriol in his words and heart.[43]

After his errand in Natchez, Jackson returned up the Trace toward Nashville. Along the way, he heard that Dinsmore had armed several hundred Indians to demand that Jackson either produce his passport or submit to detainment. Jackson, in turn, armed his most trusted black slaves and prepared for a confrontation. When he arrived at the Choctaw Agency House, there was no sign of Dinsmore. Jackson hurled some deprecatory insults at the absent agent and continued escorting his chattel to Nashville.[44] Upon his return, Jackson began to mail a barrage of letters to his influential friends condemning the un-American activities of the Choctaw Indian agent. Jackson's friends began sending off their own letters, many of which reached the desk of William Eustis at the War Department. Eustis then contacted Dinsmore and told him to be prudent when enforcing the 1802 law. Dinsmore promised to do so and, for a time, did enforce it sparingly. However, he soon began to require passports and proof of ownership again from all those traveling by his agency house.

Andrew Jackson wrote another furious letter, this time to influential Tennessee congressman George Washington Campbell. He began by telling his friend that he was pleased to hear Secretary Eustis's rebuke of Dinsmore, and he had hoped that said rebuke would settle the affair. However, Dinsmore soon returned to harassing travelers along the Trace. The detention of one traveler, in particular, a "defenceless woman and her property," particularly outraged Jackson:

> *Is it come to this, are we free men or are we slaves is this real or is it a dream…and can the Secratary of war for one moment retain the idea, that we will permit this petty Tyrant to sport with our rights secured to us by treaty and which by the law of nature we do possess, and sport with our feelings by publishing his lawless tyranny excercised over a helpless and unprotected female.*[45]

In his vitriolic style, full of grammatical errors and hard-to-follow ramblings, Jackson demanded the removal of Dinsmore. He claimed that American citizens who used the Trace would no longer allow themselves to be abused by the federal agent. In a not-so-veiled threat, Jackson was giving the government the chance to remove Dinsmore before the people got to him first:

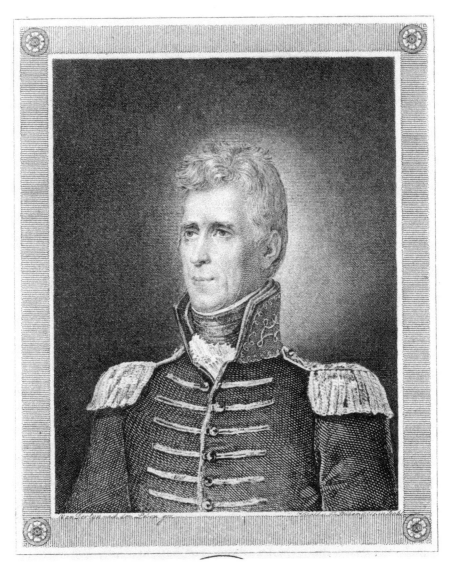

A young Andrew Jackson. *Library of Congress.*

The indignation of our citizens are only restrained by assurances that goverment so soon as they are notified of this unwarrantable insult, added to the many injuries that Silas Dinsmore has heaped upon our honest and unofending citizens, that he will be removed.[46]

27

If Campbell, and by extension the United States government, did not yet understand Jackson's position, the general made it very clear when he wrote, "[T]he wrath and indignation of our Citizens will sweepe from the earth the invader of their legal rights and involve Silas Dinsmore in the flames of his agency house."[47] Jackson had given Congress an ultimatum: remove Dinsmore through legal means or he would be not-so-gently removed by Jackson himself. He concluded:

> [W]e really hope that the evil will be cut off by the root, by a removal of the agent...if redress is not afforded, I would despise the wretch that would slumber in qu[i]et one night before he cutt up by the roots the invader of his Solem rights, reguardless of consequences...this is only Justice this we ask of Goverment—this we are entittled to, and this we must (sooner or later) and will have. This may be thought strong language, but it is the language that freemen when the[y] are only claiming a fulfillment of their rights ought to use.[48]

Silas Dinsmore was removed as Choctaw agent in 1813. He was disappointed but stayed on in the vicinity, hoping to receive a land grant in the Choctaw territory. During the War of 1812, he rallied the Choctaw tribe and offered his services to none other than General Andrew Jackson. He wrote his former adversary cordial letters on January 27, February 10 and February 11 in which he requested arms for the Choctaws he had rallied, as well as explaining how he planned to use the Choctaw as scouts. He also promised to keep away any who wished to seduce the Choctaw away from their alliance with the United States.[49]

Jackson politely thanked Dinsmore. He had his aide, Brevet Major Thomas Butler, write his appreciation to Dinsmore:

> Sir, The Majr Genl. commanding has recd your communication of the [blank] Inst. And takes a pleasure in acknowledging his obligations to you for the zeal and activity with which you have on this an many other occasions exerted yourself to collect and bring to the service of the US the Choctaws.... [T]he Genl. intends to have arms forwarded to you very soon.[50]

PATH OF THE NATCHEZ TRACE CIRCA 1820

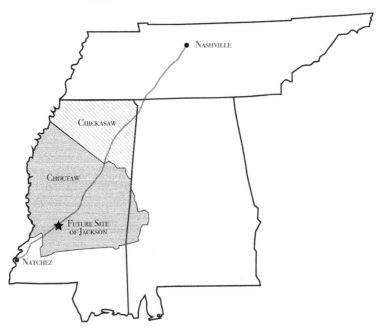

The path of the Natchez Trace showing the Choctaw Nation prior to the 1820 Treaty of Doak's Stand. *Josh Foreman, based on a United States Department of the Interior map.*

Just two weeks later, Jackson had Butler send Dinsmore another communication in which he expressed full confidence in Dinsmore's abilities and told him to lead as he saw fit: "The Genl. approves of your plan...and has the most perfect confidence in your zeal in the execution of them."[51]

The appreciation Jackson felt for Dinsmore during the War of 1812 dissipated when the British threat was no longer present. Dinsmore was present at the Treaty of Doak's Stand in 1820 when the Choctaw ceded half of their remaining land in Mississippi. He hoped to finally be officially granted the land he had chosen for himself so many years before. The white signatories Andrew Jackson and Thomas Hinds, however, did not recommend Dinsmore's land request to the War Department. Dinsmore never got his land. Dinsmore summed up his own career when he wrote later, "An agent is the Creature of the Government. The Government can create, annihilate, and resuscitate, at pleasure. In 1802, I was created. In 1814 by the foul breath of Calumny I was suffocated. In 1815 I was resuscitated."[52]

JACKSON, FROM THE MIND OF JEFFERSON

In 1802, concerned by outbreaks of yellow fever in southern cities, President Thomas Jefferson began to envision a new kind of city, one less susceptible to epidemic. He explained his plan to William C.C. Claiborne, governor of the Orleans Territory and a former governor of the Mississippi Territory. The city would be laid out "on the plan of the chequerboard," with alternating blocks of buildings and green spaces.[53] "Let the black squares only be building squares," Jefferson explained in another letter, "and the white ones be left open, in turf and trees." A city laid out in such a way would have the feel of the country and inhibit the spread of diseases, he wrote. And every house and business would look out on an open, green space.[54]

Jefferson urged Claiborne to implement his plan in New Orleans, which was undergoing expansions. He also urged that his plan be implemented in Indiana, where a new city (named Jeffersonville, after the president) would soon be placed on the Ohio River. Although Claiborne loved the idea of a checkerboard expansion of New Orleans, it never materialized. Jeffersonville was built, but Jefferson's plan was abandoned for a more conventional layout.[55]

Jefferson's vision for a checkerboard city remained an abstract concept realized only in his letters and drawings—that is, until the leaders of the new state of Mississippi began thinking about the layout for their state's capital city almost two decades later.

Mississippi became a state in 1817, and for four years, its legislature met in Natchez, Washington and Marion County.[56] In 1821, the state legislature decided that Mississippi needed a centrally located capital. The surveyor general of the state placed the geographic center of Mississippi at Doak's Stand in Madison County and tasked three men with exploring the area and finding a suitable location for a capital city. The men were James Patton, William Lattimore and Louis LeFleur's old comrade-in-arms Thomas Hinds. The men settled on LeFleur's Bluff and reported back to the legislature, which appointed Peter Van Dorn to work on a design for the new city, along with Hinds, Lattimore and Abraham DeFrance.[57]

From the start, Jefferson's wish for a checkerboard city was in the minds of Hinds and Lattimore. They broached the idea to the legislature in their

A map of Mississippi from 1835, showing large parts of the state controlled by Choctaw and Chickasaw. *Library of Congress.*

initial report about the LeFleur's Bluff location, even before Van Dorn had joined the commission. Somehow the men remembered that Jefferson had explained his vision to Governor Claiborne in a letter some seventeen years before. They argued that in addition to preventing disease and creating an atmosphere of comfort and convenience, the checkerboard plan would prevent the spread of a potential city-consuming fire. They also recognized

that Jefferson's vision had never been realized and that it was an opportunity to distinguish Jackson as a city and pay homage to the nation's third president.

"As yet, probably, this plan has not been adopted in any country," Hinds and Lattimore told the legislature, "and if first adopted in this, our State would have the merit of being foremost in an improvement recommended by an eminent American philosopher, an illustrious benefactor of his country, and a friend to mankind."[58]

Van Dorn must not have taken much convincing, as the plan he drafted the following year was a faithful interpretation of Jefferson's dream. Van Dorn's drawing had Jackson laid out on a perfect grid, with Capitol Street, State Street, Court Street and College Street cutting one-hundred-foot-wide avenues throughout the city. Developed blocks were interspersed with undeveloped blocks in the pattern of a checkerboard, just as Jefferson had envisioned two decades before. Each developed block was subdivided into eight lots. The statehouse stood at the head of Capitol Street, flanked by a courthouse and college. The space behind the statehouse was marked "commons" and presumably stretched to the Pearl River a few hundred yards away.[59]

The legislature decided that the capital city would be called Jackson in honor of another of LeFleur's old associates, General Andrew Jackson. Construction on a statehouse had begun and concluded even before Van

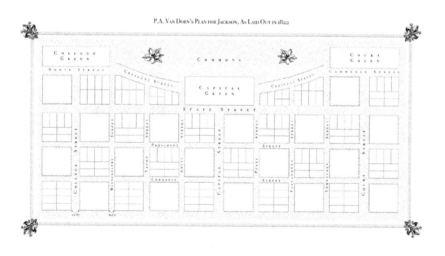

P.A. Van Dorn's 1822 plan for Jackson, based on Jefferson's design. *Josh Foreman.*

Dorn's final plan was drafted.[60] Steps had been taken to turn Jefferson's vision of a new kind of city into a reality—now if the state could just convince people to move there, build homes and businesses, stroll along Jackson's grand avenues and lounge in its commons and parks.

Hinds and Lattimore's idealism did not stop at homages to Jefferson. They also planned for the city to be a kind of state-owned-property utopia. The city would be located in an uninhabited area on state-owned land, Hinds and Lattimore told the legislature in their initial report, eliminating conflicts arising from property disputes: "The town will be the property of the State, and every individual interest in it will subserve the public good. Here general feelings may find a center of union, and patriotism a rallying point."

Hinds and Lattimore's lofty hopes for an equitable sharing of land resources did not make it past the earliest of planning stages, apparently; nine days after that initial report, the state offered "inducements" to "persons of enterprise" willing to move to Jackson. As part of the deal, ten lots within the town were given away on the condition that their owners build houses on the properties within a year and pay an average price for the lots at a future time.[61] And never mind that black slaves, who were of course not included in Hinds and Lattimore's "public good," outnumbered white men in the city from its earliest days (tax records show 242 "taxpayers" and 277 slaves).[62]

The state legislature met for the first time in Jackson in January 1822.[63] Later that year, the city offered one hundred lots for sale, asking that purchasers pay only 10 percent of the purchase price up front.[64] The city had trouble collecting the remainder of the property debts, passing an act in 1824 that extended the period Jackson residents could pay.[65]

The city sold no more lots for a decade and had very little success collecting for the initial one hundred lots it had sold. An 1830 investigation by the state auditor's office found that of the one hundred lots initially sold, ninety-eight had reverted to state ownership.[66]

Although Jackson's population remained miniscule in its earliest days, people of high stature did move to the city, many with plans of serving the legislature

in some form or fashion. In its first year as a city, three taverns opened. Two doctors had set up shop in Jackson within its first year of existence (including David Dixon, one of the "persons of enterprise" granted a lot), as well as a merchant selling groceries and dry goods. The Jackson Hotel was opened in 1823 by William Matthews, another of the "persons of enterprise" granted a lot, and offered "a large, roomy building, many rooms with fireplaces." An editor started a Jackson-based newspaper the same year, and at least three lawyers began practicing in the city.[67]

Perhaps the first account of Jackson's rise was published on New Year's Day 1823 in the *Natchez Gazette*:

> *Little more than six months have passed by since the town of Jackson was laid off, but that few persons as yet have been authorized to occupy lots therein; the great distance it lies from whence all necessary supplies are to be transported—through a country, too, where no persons resides to keep the roads in repair—and above all, when we view the number, dimensions, and style of the buildings, erected in the Town of Jackson, we cannot but admire the enterprize, industry, and perseverance of its citizens.*[68]

Another of the first accounts of the city was recorded later that year, by a teacher who arrived in the town to deliver letters. He stopped in a bar called Winn's Tavern (likely owned by Joseph Winn, another of the "persons of enterprise" granted a lot in the town[69]) and went to see the statehouse. The teacher remarked on how much the town had changed since he had passed through the previous year:

> *1 year back there was but one cabin in the place, and not one tree amiss. Now there is about 10 frame as many hewn log & one brick house, and the mechanics are very busy on all sides, they informed me that there would be another brick house put up this season & several frames. Here we may truly say that there is a city springing up in the midst of the forest.*[70]

Colonel J.M. Gallent wrote another account, from memory, of early Jackson in the *Magnolia Gazette* in 1888:[71]

> *On my way from South Carolina, my native state, I stopped at Jackson, in this state, a few days. At that time Jackson was a little hamlet in the woods. It had about six or eight houses, and all of them of a very ordinary kind. The state house was a small, plain brick building, two stories high. The*

legislature was in session at the time. The senate sat in the upper story and the representatives in the lower story. They were thus both politically and literally the upper and lower houses of the legislature. It did not take a large house to hold the members at that time.

Jackson in its second year seemed to be small but bustling. Still, some were not satisfied with it remaining the state capital. The state Senate passed a bill in 1829 that would have moved the capital to Clinton, and it very nearly passed the House as well. The House voted in 1830 to move the capital to Port Gibson and then reconsidered. The following day, members voted to move the capital to Vicksburg. Nevertheless, Jackson remained the capital.[72]

As more Mississippians moved to the capital, Jefferson's checkerboard city began to take shape. A map from 1875 shows that Van Dorn's drawing from 1822 had been fulfilled almost exactly, with the state capitol sitting at the head of Capitol Street, State Street cutting a wide avenue in front of it and blocks laid out in a neat grid. Capitol Green, Court Green and College Green still stood out as park-like green spaces, as Van Dorn had intended. The expansive commons Van Dorn had planned stretching back to the Pearl River were there as well.

Sadly, one of the most essential features of Jefferson's ideal had been mostly abandoned: the alternating green spaces between developed blocks. The 1875 map shows that the city had built its city hall on one of the green spaces, a penitentiary on another and a gasworks on another. Only one of the open spaces had not been subdivided into smaller lots.

Interestingly enough, that final green space left over from Jefferson's checkerboard ideal has survived to the present. Jacksonians can still stand in the landscaped common, now called Smith Park, and imagine what their city might feel like if the space were multiplied several times over.

An aerial view of modern Jackson reveals that Van Dorn's original plan remains completely intact—except for the use of the once-green spaces. Although his commons were eventually occupied, Jefferson's impact on the city's layout is still plain to see. And Smith Park is a forgotten link to the man whose ideas provided a bit of grandeur to a city carving itself from the wilderness.

Part II

THE FRONTIER CAPITAL, 1830s–1890s

Runaway Slaves, Running in Jackson

In the summer of 1832, the justice of the peace of Madison County happened upon James Brown, a black man, traveling through the county. The man appeared to be about thirty and wore a cotton shirt, striped pants and a black fur hat. He spoke broken English and a little French and explained to the justice that he was a free man from New York City and that he had been working on a cargo ship on the nearby Yazoo River. The justice followed the conventions of the day—presuming Brown a slave and his story a concoction, the justice arrested Brown and delivered him to the county jail. Neither the justice nor the jailer, like nearly all whites in Mississippi at the time, afforded Brown the benefit of the doubt. Brown was imprisoned.

A notice appeared in a Vicksburg newspaper soon after, with a condemnatory headline: "Runaway in Jail." Anyone with knowledge of Brown's free or slave status should come forward immediately, the notice stated, otherwise Brown would be considered a runaway slave and sold on the market. The notice mentioned the urgency of the matter, noting that Brown's health was "not good."

Whether the story James Brown told to his captors was true may never be known. The details exist only in the arrest notice printed in that Vicksburg newspaper. James Brown may really have been a free steamboat worker

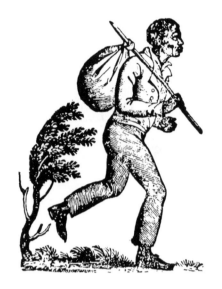

This kind of image would often accompany runaway slave notices in early 1800s Mississippi. *Josh Foreman, based on a newspaper clipping held by the New York Public Library.*

from New York City; there were hundreds of free blacks working on steamboats on the Mississippi River in antebellum times.[73]

Then again, the story could have been a complete fabrication. Slaves living along the Mississippi were familiar with the steamboats that ran up and down, and concocting a story about working on one would have been relatively easy. Brown very well may have been a runaway slave. There were many moving about in the Jackson area in the early decades of the nineteenth century, and when they were caught, they often made up stories about who they were, where they were from and what they were doing.[74] The broken English he communicated in could mean he was from Africa—there were still African-born slaves in Mississippi at the time, although the transatlantic slave trade had been abolished two decades before.

What is sure is that when Brown was arrested by the Madison County justice of the peace that day in July, he became ensnared in a stacked-odds system from which escape was nearly impossible. Brown's story, while unique in some of its details, is one of many tales of runaway slaves told through newspaper advertisements in early 1800s Jackson. Sometimes the advertisements offered rewards for the apprehension of specific slaves, and sometimes they notified owners when a slave had been found. They always included details about the individuals in question—scars and disfigurements, mannerisms, clothes, possessions, short histories and more.

The ads provide a more personal look at a practice that had metastasized in the Mississippi of the nineteenth century, showing the desperation of slaves and their willingness to escape, the cruelty of masters, the cavalier attitude with which humans were hunted and captured and the scope of the system.

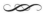

To understand the racial dynamic in Jackson in its earliest days, it is important to know a few key details. First, the opening up of Choctaw land to white settlers in 1820 facilitated a huge influx of whites to Mississippi. Those whites were hoping to make a fortune planting cotton, and slave labor was an essential component of the business model. Joshua Rothman summarized the zeitgeist in his 2013 book *Flush Times and Fever Dreams*:

> *Every white man intending to plant cotton in Mississippi aimed to own slaves, and those who already owned some aimed to increase their holdings.... The more slaves a man owned, the more land he could cultivate and the more cotton he could bring to market. It was no secret that slave labor made everything about the flush times possible.*

Second, Jackson in the first decades of its founding was not a city but a village, a backwater overshadowed in size and stature by its neighbor Clinton. One historian described the state of the capital in 1835, noting that the town was "little more than a half-mile square of ground cleared from the forest." It had about six hundred residents and no church or school.[75] Hinds County, more broadly, however, had eight thousand residents in 1830. Madison County, with which Hinds shared a porous and artificial border, had several thousand as well.

"In the Swamp." *Library of Congress.*

Hinds and Madison Counties were known to have some of the best farmland around. During the 1830s, the two counties saw massive population growth. The growth of the slave population far outstripped that of the white population, however. By 1840, Hinds County was about two-thirds slave, and Madison County was about three-quarters slave. In 1840, there were more than twenty thousand slaves in the two counties, along with far fewer whites.[76]

The population trends in Hinds and Madison Counties mirrored the trends in the state more generally. Between 1820 and 1850, the slave population in Mississippi grew from 33,000 to 437,000.[77] By 1860, there were about 50,000 more slaves in Mississippi than whites.[78]

Third, the Jackson area was close to several key geographical features that made it a good place to run away from—or to. Waterways provided an essential means of travel for escaped slaves, who often moved about in canoes or rafts. Jackson was about forty miles from the Mississippi River, perhaps the biggest symbol of hope for enslaved southern blacks. The Pearl River and Big Black River also flowed through the area. The Yazoo River wasn't too far, either. Jackson was also relatively close to the Louisiana state border; runaway slaves from Louisiana would cross over the border and flee through Mississippi in the hopes of thwarting authorities in their home state.[79]

James Brown was one of many blacks who attempted to traverse, unfettered, the Jackson area in the early 1800s. Each advertisement tells a snippet of the runaways' stories. In most cases, including Brown's, the fates of the runaways are sadly unknown.

In 1827, a well-dressed slave named Nick, "slightly marked by the whip," was caught fleeing Natchez through Hinds County. Nick had been sold sometime in the past and shipped from Maryland to Natchez. Many of the slaves brought to Mississippi in those decades came from other parts of the country, and the trauma of leaving their communities behind made their bondage in Mississippi harder to bear.[80]

A Hinds County slave owner named John Grimball took out an ad in 1838 offering a $100 reward for the return of his slave Nathan. Only seventeen or eighteen when he ran away, Nathan had lived in Vicksburg before being sold and moved to Hinds County. Grimball feared that Nathan was back in Vicksburg. "It is probable he may endeavor to make his way up the river to some free state," Grimball wrote in the ad.[81]

Tom was another slave with knowledge of Vicksburg and the Mississippi River vicinity. A horse driver, he had made the trip from Clinton to Vicksburg regularly for two years. Then, in 1834, he ran. His master, Samuel Brown, suspected that he was headed up the river.[82]

Sometimes slaves fled in the opposite direction. Squire Warren and Billy, two slaves sold and shipped from Tennessee to Warren County in the

winter of 1833, were caught a few months later making their way through Rankin County.[83]

Joe Bass, who also went by the name Joe Strother, utilized a common ruse of the day to aid in his escape: forged papers. Bass was the manservant of a Hinds County man named Jesse Bass. The slave was unusually stout, intelligent and a fluent speaker with a "countenance remarkably pleasing." Bass had been living in Jackson for a year when he disappeared in 1834. He left behind a "free pass" bearing the names of the Mississippi secretary of state and governor, respectively. Bass's intelligence and "remarkably pleasing" personality did not stir in his master any compassion; the master offered a $100 reward for the return of the man, "dead or alive."[84]

In 1839, a slave named Bill escaped Hinds County and made it all the way to Natchez before being caught. Adams County, where Natchez was located, was a notoriously difficult place for escaped slaves to navigate without being caught.[85]

Often slaves caught in the Jackson area had escaped from masters in Louisiana. There were 342 advertisements for Louisiana runaways listed in Mississippi newspapers in the early 1800s.[86] A single issue of the Jackson-based *Weekly Mississippian* from 1833 shows the frequency with which Louisiana slaves traversed Hinds, Madison and Rankin Counties. Stacked atop one another, four advertisements detailed the plights of several Louisiana slaves: Tom, likely African-born, escaped from Orleans Parish and was arrested in Rankin County. Jim, who fled his master's steamboat with two other men at a stop on the Mississippi River (it is unclear what state the three men resided in), was caught in Madison County. William fled Covington, Louisiana, and made

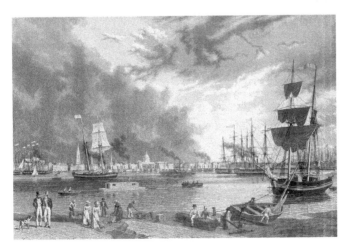

New Orleans as it appeared in 1842. *Library of Congress.*

it to Hinds County, where he was arrested. Peter, Frank and Lewis, three slaves recently moved from North Carolina, fled Carroll Parish and were suspected to be fleeing back toward North Carolina via Clinton. Their masters, two brothers from North Carolina, offered $150 for their return.[87]

Although many slaves fled Louisiana for Mississippi and the free North, many slaves also made their way to New Orleans. Runaways hid out in the sprawling city, procuring "underground resources," as one historian put it, hoping to escape on an Atlantic-bound ship or a steamboat heading upriver.[88]

So how likely was it that James Brown really was a free black man from New York City?

Steamboats were one of the most common avenues for work for free and enslaved blacks of the time—there were many free blacks traveling up and down the Mississippi River.[89] The boat that Brown claimed to have been working on, the *Talma*, was a "splendid" steamer, as one Kentucky paper described it, "fast-running and light" and well known on the river.[90] In the three years that Brown might have worked on the ship, it made regular trips between Yazoo City (known then as Manchester) and New Orleans, hauling passengers and goods including kegs of flour, lard, bacon, ham and butter.[91]

On its regular route, the *Talma* would head up the Mississippi from New Orleans, stopping at Natchez, Vicksburg and other points. At Vicksburg, it would turn off the Mississippi and head up a tributary—the Yazoo River. Winding its way up the Yazoo, the *Talma* would pass within ten miles of Madison County. It is entirely possible that Brown really had been a free black crewmember, drawn from his boat on the Yazoo River into Madison County for some reason—leisure, an errand, a woman, by mistake. The sad fact is that whether he was free or not, he became unfree when a Madison County official decided to meddle in his business.

Although James Brown claimed to have worked the Mississippi on a steamboat named *Talma*, another boat named *Talma* was plying waters farther south at the same time. The packet ship *Talma* made frequent trips between New York and New Orleans in the late 1820s and early 1830s, sailing from New Orleans into the Gulf and then around the Florida Keys and up the Atlantic seaboard.[92]

It could be that Brown had made his way to New Orleans on a similar ship, watching the tropical scenery pass as the boat rounded the Florida

Keys. And it could be that Brown made his way back to New York that way, after his captain, coworker or someone else visited the jail in Madison County and explained that he was indeed free and should be released. But it isn't likely.

Madison County's Great Slave Rebellion

John Murrell was in a rage. The family of black slaves he was helping to escape were supposed to make him a lot of money. Instead, they had become an irritating problem.

It was the early 1800s, and Mississippi was still a frontier. Murrell had made a living out of traversing its wilderness, cheating and stealing. This particular scam involved convincing a slave to escape, leading him to another part of the frontier and then selling him.

Murrell's latest accomplice turned victim was a slave named Clitto. Murrell had convinced him to run away from his master. "I have carried off a great many like you," Murrell had told him, "and they are all doing

A section of the original Natchez Trace near Jackson. *Josh Foreman.*

well, all got homes of their own and making property up North. I'll push you through."[93]

Clitto had agreed to run away that very night and met Murrell at their prearranged rendezvous. However, Clitto brought his wife and three young children with him. Not happy about the presence of the family, Murrell nonetheless pushed on. When the company came to a swamp, Clitto led the way, claiming to know a rarely used path. Soon they were lost in the slushy swamp, surrounded by slithering snakes and the rumbling barks of alligators. The six of them found a raised piece of land and spent the night. In the morning, Clitto admitted that he was lost.

After a second day sloshing through the swamp, the weary travelers found a bark canoe and began to make some progress. But then Clitto began to ask question after question in what Murrell determined was a complaining tone. Murrell had had enough. He pulled out his pistol and, without a warning, shot Clitto dead. He whipped around and smashed the discharged pistol into the face of Clitto's screaming wife. The children leapt from the canoe and tried to run away, but Murrell caught and disposed of each of them, leaving their little bodies floating in the swamp. Finally, he returned to the shocked and sobbing mother, calmly loaded his pistol and shot her dead.

Murrell then continued on his way, determined to find another slave—one who would keep his mouth shut and bring his liberator a nice profit.[94]

By the 1830s, the story goes, Murrell had learned that committing crimes as an individual was not lucrative enough; to really profit, a man needed to be part of something larger, a "clan"—and Murrell had done just that, becoming the leader of his own criminal conspiracy, the Clan of the Mystic Confederacy.[95]

His career as an outlaw began to unravel in 1834, when he boasted to a suspicious fellow traveler after stealing the slaves of a Mr. Herring in Tennessee.

One of Herring's young friends, Virgil Stewart, alias Mr. Hues, suspecting Murrell had stolen the slaves, caught up with him as he traveled down the Natchez Trace from Tennessee to Arkansas. They made conversation, and Murrell spoke admiringly of one "John Murrell" for quite some time in the third person before he finally revealed his true identity to Stewart. He

John Murrell as he appeared after being captured. *Josh Foreman, based on a print held by the Cincinnati Digital Library.*

told Stewart of his many talents, crimes and villainies. Soon enough, he even told Stewart of his greatest project, the Clan of the Mystic Confederacy: "My clan is strong, brave, and experienced, and rapidly increasing in strength every day. I should not be surprised if we were to be two thousand strong by the 25th of December, 1835."[96]

Having a devoted two-thousand-man army in 1835 when Jackson, the capital city of Mississippi, only had six hundred residents, was a bold claim.[97] But Murrell continued: "At least one half of my grand council are men of high standing, and many of them in honorable and lucrative offices."[98]

They can never [convict] *him unless they can find the negro; and that they cannot do for his carcass has fed many a tortoise and catfish before this time, and the frogs have sung this many a long day to the silent repose of his skeleton and his remembrance recorded in the book of mysteries.*[99]

Thus, Murrell boasted to Stewart of the disposal of another accomplice turned victim. Sometime earlier in his career, he had convinced a slave of Tipton County, Tennessee, to run away from his harsh master. Murrell promised him freedom if only he would allow himself to be sold, run away and be sold again until the two, Murrell and the slave, reached the free states. Murrell then promised to split fifty-fifty the money that they had accumulated along the way. The slave agreed, and he ran away one night, meeting one of Murrell's friends at the prearranged destination. The friend took the slave down the Mississippi River in a skiff to Natchez, where he left the runaway with a second friend of Murrell's. Murrell himself then arrived on a second steamboat and picked up the slave, and the two headed down to New Orleans.

While aboard, another passenger recognized Murrell and reported his scheming to the captain, who in turn confiscated the slave and had Murrell placed under guard. Yet as the boat was docking, Murrell made his escape and rallied his friends in the area, including the mayor. He filed suit against

the captain, recovered the slave and had the captain hit with a fine and imprisoned. As to the informer aboard the steamship, Murrell reported that "he found his way to the bottom of the Mississippi river, and his guts made into fish bait."

When Murrell and his black accomplice reached New Orleans, Murrell sold him for $800. Shortly after, the slave ran away and returned again to an $800 richer Murrell, who had now taken on the persona of a Methodist preacher. Preacher Murrell told his flock that he had recently decided to rid himself of his slaves, having concluded that slavery was wrong. However, the young boy with him refused to leave his master's side, so devoted was he to Murrell.

But then the slave fell in love with another slave in the Methodist community and convinced her master, Brother Hiccombatan, to buy him. He did, for $700. Once again, the slave ran away, back to Murrell in Kentucky. Murrell then sold him for another $500. Then he stole him again.

Having made $2,000 off the slave, Murrell decided not to press his luck any further and buried him in a swamp.[100]

Murrell also supposedly confided in Stewart about a plan he and his Mystic clan planned to enact soon. Murrell was organizing to foment a massive slave insurrection across the South. In the chaos that ensued, Murrell and the Mystic clan would ride through the countryside plundering.

"I look on the American people as my common enemy," Murrell had supposedly said to Stewart. "They have disgraced me, and they can do no more; my life is nothing to me, and it shall be spent as their devoted enemy."[101]

Murrell had provided Stewart with more than enough stories for Stewart to report Murrell to the authorities. He did, and Murrell was arrested in Tennessee. Stewart headed north to Kentucky, where he felt, according to the story, safe from any Mystic clan conspirators looking to avenge their leader's arrest. In Kentucky, Stewart wrote and published an illustrated pamphlet detailing Murrell's villainies. Whether anything Murrell had told Stewart, or anything Stewart had sworn to, was actually true, the publication of the pamphlet sent fears of a slave rebellion throughout the South. Stewart had friends in Madison County, and it is likely that he distributed his pamphlet there while visiting.[102]

And so it was that the fears of a Mystic clan–led slave insurrection reached the Jackson area. Soon after the publication of the pamphlet, a Mrs. Latham in Madison County stood eavesdropping on two of her female slaves.

"But this here is such a pretty little baby!" she heard one say. "You all ought to know I never could kill that child!"

"When that day comes you-all got to, gal," she heard the other reply. "Won't be no never-could about it. Us got to kill them all!"

"Go on kill all you-all wants. Won't nobody touch this lamb here. I won't let them touch him!"

When the conversation concluded, Mrs. Latham hurried to her husband. Her husband, in turn, rode from plantation to plantation, spreading the alarm to his fellow white planters.[103]

On June 27, 1835, concerned citizens of Hinds and Madison Counties met at Livingston to discuss the potential slave uprising. They appointed patrols and committees of investigation and decided to reconvene on June 30. When the citizens reconvened, planter William P. Johnson reported that he had instructed his black driver to gather what information he could. An old black field hand of Johnson's revealed the plot to the driver, although he did not know many details. He suggested that the driver get in touch with Ruel Blake's slave, Peter, in Livingston. Peter had the gunpowder and further information. The black driver reported the ominous news to his master.[104]

The council called in Johnson's slave, who at first denied his purported conversation with the driver. However, in the midst of a whipping, the old slave confessed. He revealed that Peter and a slave of Captain Thomas Hudnold's were the two ringleaders. Hudnold's slave had already fled to the swamps. When he was captured, the committee ordered him hanged, where on the gallows he confessed to the uprising and that he was supposed to kill his master. But beyond that, he knew few details.[105]

More slaves were implicated. The extralegal committee ordered them hanged. "[T]he nine or ten negroes who had been questioned were led out, roped hand to hand and leg to leg, to a grove of cottonwoods along the Big Black River and there hanged."[106] As the slaves were being whipped and hanged, a number of them began to speak the names of white conspirators. Jesse Mabry, one of the members of the committee, explained the rapid course of events in a letter dated September 20, 1835, two and a half months after the climactic events at Livingston:

[A slave named Joe revealed] *the negroes were going to rise and kill all the whites on the 4th, and that they had a number of white men at their*

head: some of them he knew by name, others he knew only when he saw them. He mentioned the following white men as actively engaged in the business: Ruel Blake, Drs. Cotton and Saunders, and many more, but could not call their names; and that he had seen several others.[107]

Mabry further explained the details of the conspiracy: the slaves, with the guidance of an unknown number of local white men, would at first use axes and hoes to slaughter their masters. They would then converge on Beatie's Bluff to get weapons and then move on to Livingston. They planned to recruit slaves and kill whites all the way to Clinton, where they would plunder a bank and then rally at the Punch Bowl in Natchez. By then, they expected to be strong enough to repulse any retaliatory force.[108]

The black slaves, of course, expected their freedom. The white instigators, however, wanted more. They planned to enrich themselves during the chaos that followed. As Dr. Joshua Cotton explained, "Our object in undertaking to excite the negroes to rebellion, was not for the purpose of liberating them, but for plunder."[109] It was the plan Murrell had hatched the year before:

When the negroes commence their carnage and slaughter, we will have detachments to fire the towns and rob the banks while all is in confusion and dismay. The rebellion taking place every where at the same time, every part of the country will be engaged in its own defense, and one part of the country can afford no relief to another until many places will be entirely overrun by the negroes, and our pockets replenished from the bank, and the desks of rich merchants' houses.[110]

The council at Livingston decided that even more drastic measures were now necessary. Hanging a few obscure black leaders would not pacify the area. But if white leaders were hanged, too, then the rebellion would certainly be forestalled.[111]

At 9:00 a.m. on July 3, the day before the rebellion was to begin, 160 citizens of Hinds and Madison Counties gathered and created a Committee of Safety. The committee of vigilantes anticipated a valid objection to their extralegal form of justice: why not allow legitimate civil authorities deal with the potentially volatile situation? The committee peremptorily responded:

The civil authority was inadequate to this end in Madison County; for there is no jail in that county sufficient to contain more than six or eight prisoners, and even those vary in security, and, whenever prisoners would have been

despatched to any other county, a guard would have been required, which
would have left many families defenseless; and it was unknown at what
moment this protection might be required.[112]

Furthermore, the committee made an appeal to the law of self-preservation. The primary duty of a government is to protect the lives of its citizens. When such protection cannot be provided, then the citizens have a right to take the necessary measures to protect themselves. The committee gave the power of life and death to a panel of thirteen judges, of whom nine would make a quorum.[113] Then began the trial of Dr. Joshua Cotton.

Dr. Cotton had lived in Mississippi for twelve months, having moved from New England. By trade, he was a steam doctor, but according to William Saunders, the chief witness against him, Cotton also bought stolen goods from slaves and thereby encouraged such theft. He was in Memphis with his wife and child when Murrell was sentenced to the penitentiary. When he moved to Mississippi, he was single; the whereabouts of his family remain a mystery.[114]

From the confessions of a number of slaves, the committee ascertained that a white man had been riding among the plantations on the pretext of looking for his lost horse. He would then get to know the slaves, sometimes even drinking brandy with them, and reveal his promises of rebellion and freedom. Yet no one knew the identity of this white instigator.

Meanwhile, William Saunders was in Vicksburg telling a local about the slave rebellion over in Madison. Something seemed amiss, and Saunders was placed under arrest and returned to the committee at Livingston.[115]

Back in Livingston, a black boy was found who had met the mysterious white provocateur. The boy was brought to the room, where the proceedings were gaining momentum. The boy saw Dr. Cotton and identified him as the culprit. When coupled with Saunders's testimony against his former conspirator, the boy's evidence was damning, and Cotton knew it. As he was being dismissed so that the judges could deliberate and decide his fate, he offered to reveal the plot provided he was given assurances that he would not be hanged. The judges offered no such assurances.[116] Instead, they voted to hang Dr. Cotton.

With his death imminent, Cotton confessed and revealed what he knew about the plot, in a signed statement:

I acknowledge my guilt, and I was one of the principal men in bringing
about the conspiracy. I am one of the Murrell clan, a member of what we

called the grand council....Our object in undertaking to incite the negroes to rebellion, was not for the purpose of liberating them, but for plunder. I was trying to carry into effect the plan of Murrell as laid down in Stewart's pamphlet.[117]

Cotton also revealed the name of a number of co-conspirators, many of whom lived in Hinds and Madison Counties. Nevertheless, the committee ordered Cotton to be hanged within one hour in the hopes that news of his death would spread rapidly and forestall the uprising. While he stood on the gallows, he said he accepted his fate, that he deserved it and that everything he had written in his confession was accurate. He asked that God take vengeance on him if it were not so. A witness then asked him if the danger was real, to which Cotton replied in the affirmative. He said that hanging him might deter the conspirators. He warned the crowd, "Take care of yourselves to-night and to-morrow night," and then he was silenced.[118]

Over the next several days, six white men and at least a dozen slaves would meet the same fate as Dr. Cotton. The fear of a slave rebellion, real or imagined, had been allayed.

THE TENACITY OF THE MANSHIP FAMILY

As the sun set on a November day in 1879, Jessie Manship stood at the eastern end of the family hall, next to another beautifully clad woman—her sister, Jennie Manship. Both waited to be married. Earlier that day, Jessie had put on her chemise, pantaloons, corset, corset cover, bustle, camisole and petticoat in anticipation of her dream evening. So did her sister. The two stood by each other looking radiant with noticeable orange blossoms on their bridal outfits. The orange, after all, was a symbol of fertility. Tomorrow morning, the orange would be discarded; it would be bad luck to wear it after the wedding day.[119]

It was now a quarter 'til eight, and the two ladies stood like statues to be admired as the guests continued to pour in. The food was already on the table. When the ceremony that would bind them for eternity was over, the two women would join their guests for a once-in-a-lifetime feast. Certainly, they would attend other weddings, but who would, or could, throw a finer feast than their own mom and dad, Adeline and Charles Manship?

Adeline Daley Manship looked on, recalling her own wedding thirty-one years before. At fifteen, she had married an up-and-coming, new-to-the-city transplant named Charles Manship. Manship had left his home in Talbot County, Maryland, in 1835 and arrived in Jackson in 1836, the year after the Mystic clan was exposed in neighboring Madison County. The young man who would soon be her husband had arrived in Vicksburg penniless—he hadn't enough money to buy a horse, so he had walked to Jackson.[120]

Adeline hailed from a Boston family. Her father had worked on the woodcarving for Jackson's Governor's Mansion and the capitol building—the same building that would play such an important role in her adopted state's history, and her own, in the next two and a half decades. After her own marriage, Adeline had moved to her new house on North President Street. Nineteen years later, she had helped move her family into what would become known as the Manship House on 412 Fortification Street. After fifty-seven years of marriage and fifteen children (Mary Rebecca,

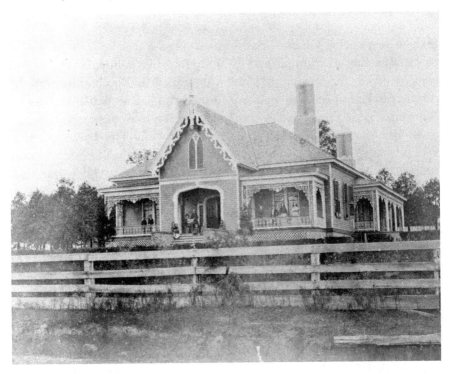

The Manship House (and family) one year after the weddings of Jessie and Jennie Manship. *Library of Congress.*

James Daley, Charles Henry, David Daley, Harriet, Louisiana, Adeline, Catherine, Luther, Anna Jane Jones, Jessie, Boyd Montgomery, Jane Dudley, Vicksburg and Florence Lee), she would be buried in nearby Greenwood Cemetery. For better and for worse, Jackson had become Adeline Daley's home.[121]

At eight o'clock that evening, the two sister-brides were finally revealed. Jessie and Jennie were joined by their fiancés, Charlie Brougher and Jeff Davis Gordon. Right Reverend Doctor Watkins oversaw the exchange of vows, while guests from St. Paul, Minnesota, to south Mississippi looked on in approval, waiting for the ceremony to end and the feast to begin.[122]

Sixteen years prior, Charles Manship had risen to the position of mayor of Jackson. But his triumph had begun to look like failure; his mayorship coincided with the sacking of Jackson in 1863. Manship had handed the city over to Union general Ulysses S. Grant, who had set it aflame. Charles Manship's achievements seemed to have gone up in smoke as well.

St. Peter's church was set ablaze. The Bowman Hotel was in ruins. Federal troops walked through the dining room of the Manship House, smashing china and overturning a barrel of molasses. They started a small fire in a corner of one of the rooms. The elder Adeline had been trying to hide some of her family's valuables, tying silver around her waist in the hopes of preserving it. Before, she had ordered her slaves to remove the wheels of the family cart and to hide them in the pond for future use.[123]

The banquet was ready. The guests attacked the tables laden with food. They loaded their plates with their choice of savories: oysters from Biloxi, redfish and flounder from Pascagoula, hams from St. Louis and Chicago, salads from the Grouse of Minnesota, salmon chowder from Oregon and

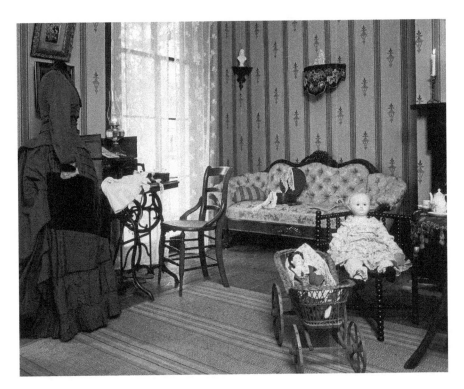

This page and next: A room of the Manship House. *Library of Congress.*

Alaska, oranges and bananas from Havana, coffee from Java, teas from China, cakes and candies from Martz in Jackson and a bridal cake with its magic ring and crystal floral crown.[124]

With Jackson burning all around them, the Manships had feared the worst. Their house, however, had not met the fate of much of the city. Instead, Union officers had decided to use the Manship House as an officers' quarters. Adeline Manship had taken the news as best she could and had even managed to get along with her uninvited guests. She kept her house in order. Perhaps being a native Bostonian herself helped ease the tension. "It took a Yankee to get ahead of these damyankees!" she later said.[125]

A year after the fall of Jackson, Charles, who had been appointed postmaster by Jefferson Davis on February 11, 1864,[126] received a letter

from a friend of his son's: "Dear Sir was in prison [in] Natchez Miss—in company [with] a son of yours he was captured not five miles from Natchez…he was in fine spirits and I heard him complimented by the yankees as a gallan soldier."

Charles's son, David Daley, had organized a company during the war on behalf of the Confederacy. He had been captured and was then sitting in a Union prison in Rock Island, Illinois.[127]

The sitting room was full of gifts, representations of the respect and esteem in which the couples were held. They also represented the wealth of the givers. Oftentimes, the gifts and the givers of those gifts would find their way into the local newspapers. When the Manship children's youngest sibling, Florence Lee, married Edgar E. Smith of New Orleans, the paper printed the following gift list:

Presents were mostly solid silver. The father, a handsome Bible; mother, silver jelly spoon; Chas. Manship, silver berry dish; David Manship, silver knives; Kate and Addie Manship, teaspoon and butter knife; Luther Manship and wife, silver cream ladle; D. Gordon and wife, set silver forks; Mrs. Jas. Galceron, silver butter dish; Miss T. Phelps, handsome hand-painted chinaberry.[128]

The party went on until midnight, and "the fountains continued full flowing until the joyous feasters became exhausted receivers, and post-prandial satiety succeeded submerged digestion."[129]

Charles Manship exemplified the early spirit of Jackson. He was a transplant and an entrepreneur, a true self-made man. He had used his skills as painter and handyman and made a life for his large family. His paint and glass store had been a success. He helped to organize the Methodist church where Galloway Memorial Church now stands. He organized Jackson's first volunteer fire department at a meeting in his own house and was made captain of the volunteers. When the department was taken over by the city, it presented its beloved captain with the old fire bell that used to call the volunteers when a fire broke out as a token of appreciation. He had fathered fifteen children with Adeline, ten of whom survived into adulthood. He had built the spacious home on 412 Fortification Street. And he had been father of the brides at one of the most lavish and memorable weddings in nineteenth-century Jackson.

On Wednesday, December 12, 1888, Charles and Adeline celebrated the golden anniversary of their own wedding. Their ten surviving children were all in attendance, as well as all twenty-eight grandchildren.[130] At the time, Charles was the oldest resident of Jackson.[131] He would pass away seven years later and was buried at First Methodist Church. The funeral was presided over by Bishop C.B. Galloway and Dr. A.F. Watkins, the man who had married his daughters Jessie and Jennie sixteen years before.[132]

Resolved, that in his death this board has lost one of its most valued and honored members, the community one of its oldest and highly respected citizens, and society a good and worthy gentleman.[133]

Thus stated, the trustees for the Institute for the Blind voted unanimously to honor Charles Manship the day after his death. The *Clarion-Ledger* recorded his final moments: "Mr. Manship's voyage over the dark river was sudden and painless. He was walking up and down his gallery with his wife when he said to her, 'I do not feel very well and will sit down.' He sat down in an easy chair and at that moment his spirit took flight—he was dead."[134]

Adeline followed her husband eight years later. According to the *Clarion-Ledger*, she was the oldest female resident of Jackson at the time.[135] The paper proclaimed in her obituary, "Since girlhood this aged lady had watched the transition of the then struggling village of Jackson to the proportions of a thriving city. She has witnessed the coming and going of generations, and during this long and eventful period none have been held in higher respect or greater esteem."[136]

The two are buried at Greenwood Cemetery, "just a short distance from the home where they spent so many happy, useful years."[137]

A CITY SACKED, A CHURCH DEFILED

On May 21, 1863, William Henry Elder, the Catholic bishop of Natchez, received unpleasant news. The diocese's church and school in Jackson, St. Peter's, had been burned to the ground by General William Tecumseh Sherman's troops five days before. The presbytery of the priest, Father Francis Orlandi, had also been destroyed. Barrels of tar had been stored in a shed just behind the church. As the Union soldiers began to retreat, their commanding officer had ordered a detachment to burn the tar.

Father Orlandi had rushed up to the officer and begged him to roll the barrels into the street so as not to destroy the church. He pleaded and delayed for fifteen minutes, but the officer refused the priest's request. The tar was set alight, and the church and its surrounding buildings were consumed by the raging flames.

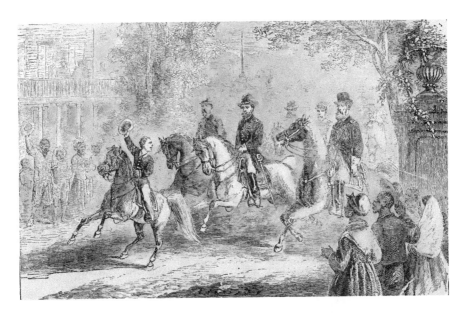

Print showing Ulysses S. Grant's 1863 sacking of Jackson. *Library of Congress.*

Fortunately, Father Orlandi and Father Francis Xavier Leray were able to save the ornaments and furniture from the flames. The priests were assisted by a surgeon in the Union army, Dr. Hewitt, who had also unsuccessfully begged the commanding officer to spare the church.[138]

Sister Mary Ignatius Sumner was in the vicinity of St. Peter's church when the order came to set the tar afire. She heard Dr. Hewitt beg the commanding officer to leave the church be and heard the officer refuse the request. The priest, with tears in his eyes, went into the church with Dr. Hewitt and came out carrying the Blessed Sacrament—the consecrated bread and wine used for communion—and said to the officer in charge, "You would not dare to insult me, but that you know my office prevents resentment."

Meanwhile, Union soldiers ransacked the church as the tar began to burn. The officer then ordered the hoses to be slashed so that there would be no chance of saving St. Peter's.[139] The church was completely destroyed.

With the help of local Catholics and the Sisters of Mercy, the priests decided to fix up a new church in a large wooden hall. They did so immediately,

celebrating mass within the week. Then, one week after Union troops had burned the church, General Sherman returned. The Union troops ransacked the new church, stealing vessels and smashing the crucifix.[140]

Again the church was moved, this time to a small chapel above the engine house. It, too, was taken over by Federal troops in February 1864. Two of its statues were destroyed, and its altar was confiscated for use as a butcher's block.[141] For a fourth time, the church was relocated, this time to the northern part of city hall. Father Orlandi took it upon himself to visit General Ulysses S. Grant, who had accompanied General Sherman, and seek compensation for destroyed church property. He was turned away.[142]

The priest was so distraught at the continual carnage being inflicted on his parish that he asked Bishop Elder permission to return to his home in Italy. He received permission but remained in Jackson for two more years.[143] With one church after another destroyed or ransacked, parishioners had resorted to holding mass above a saloon.[144]

After the sacking of the city, Union troops had departed, leaving the ruins of the city to be reoccupied by Confederate forces. The church moved to the chapel in Jackson's still-standing hospital. Father Leray, who had been pastor at St. Peter's from 1852 to 1857, again took a leadership role in the church. Then, two months after first sacking Jackson, Union forces returned, laying siege to the city. Jackson was under constant bombardment from Federal cannons for forty-seven days. Mother Mary Bernard later recalled the constant dread in which the sisters lived. The city was burned or burning, the church in ashes and cannonballs constantly and sporadically exploding. Fortunately, the hospital was left untouched, and the sisters were able to continue their ministry to the wounded.[145]

Sister Mary Ignatius Sumner and her fellow sisters endured the bombardment, "feeling every moment would be their last." Father Leray even made his will before saying a mass in the hospital chapel.[146]

It finally became clear to the nuns that Jackson could no longer be defended and that the city would be abandoned to Federal troops. At four o'clock in the morning on July 15, 1863, they crossed the Pearl River. They slept in a small, unkept cottage, taking turns napping on the one remaining bed in the residence. On July 16, they boarded a train to Meridian, leaving the smoking city behind.[147]

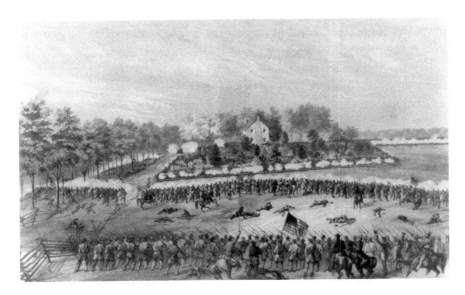

"The Battle of Jackson." *Library of Congress.*

Bishop Elder, in Natchez, resolved to take stock of the city himself. He began the journey on July 9 but was turned back at Hazlehurst by an order from Confederate general Joseph E. Johnston.[148] One week later, Elder tried again but was stopped by a washed-out road and again forced to delay his visit.[149] He decided to approach Jackson from the east and traveled to the city of Brandon, but no trains were running into the capital and no one would lend him a horse for fear of it being impressed into the army.

In addition, General Johnston's army filled the road on its retreat from the besieging Union army.[150] The bishop finally made it into Jackson proper on July 20. He was shocked at the extent of the destruction and that night wrote in his diary, "In the warm ashes & ruins at every step. Melancholy desolation."[151]

He met up with Father Orlandi, who reported that the temporary chapel he had built in which to say mass and offer the sacraments had itself been burned to the ground. The crucifix and chalice had been stolen by Union soldiers, the chalice passed around and used as a drinking cup. Fortunately, both had been returned by a sympathetic Catholic Union soldier. Father Orlandi was not so fortunate when it came to his personal possessions. All of

the priest's clothes and food had been stolen, and he was subsisting on crackers. Bishop Elder reported being choked "with sadness & indignation."[152]

Later that evening, the Union chaplain, Father Carrier, invited Bishop Elder to eat and sleep in one of the Union general's quarters. Bishop Elder refused, however, saying, "When our poor flock is in such distress I thought it would be unfeeling."[153] Father Carrier also invited the bishop to say mass in the Senate chamber, but again Elder declined, citing that he did not at the time feel it appropriate.[154]

The next morning, Bishop Elder saw the devastation in Jackson firsthand. It was an unforgettable and appalling sight. He recorded in his diary that a quarter of the city had been destroyed. Entire blocks no longer existed. The stores had been plundered. Many of its citizens were making the sad exodus to Alabama, others to the mercy of the Federal army at Memphis and Vicksburg. Bishop Elder recorded:

> *Most of the people are living on rations from the Federal Army....There is nothing in town to eat: all the neighborhood is desolated:—from a distance nothing can be brought. There are no teams & no roads—no bridges. The policy seems to be to make Jackson untenable, for soldiers or civilians.*[155]

Later that night, Bishop Elder stayed in the house of one of the burned church's parishioners, Angelo Miazza, in "his little crowded room."[156] The rest of Miazza's house and his saloon had been burned. After Bishop Elder made temporary sleeping arrangements for Father Orlandi and arranged for a replacement chapel to be set up in a room rented by Angelo, he left Jackson for the city of Canton. As he left the ruined city, he stopped briefly at the insane asylum, which would later become the focus of a push to relocate Mississippi's universities. Once outside Jackson proper, he saw more burned plantations and the destruction that accompanied the Union army. He traveled through Madison, where John Murrell's planned Mystic Confederacy had come to a violent end, and then arrived in Canton on July 22.

Bishop Elder did what he could to help the citizens east of Jackson and then decided to visit Vicksburg. On his return westward, he came across an all-too-typical scene. Elder recorded stopping to get a drink of water from an unnamed man. The man's house and all his furniture had been burned. All 150 of his cattle were gone, as were every horse and mule. He had only 10 pigs left of his original 300. His vegetable and fruit gardens had been destroyed. Bishop Elder wrote:

*All the clothes of the family destroyed save what they wore:—himself, wife,
& children were sheltered in a very poor Negro cabin, of which the shingles
were all split & curled up. The poor man was taking it all apparently with
cheerfulness—but at last his voice choked—& he said—"If crying would
do any good, I could cry all day."—I hardly knew what to say for comfort
or counsel—but I advised him to go to the camp & ask the general to give
him a mule, to plough some ground & try to raise something to eat.*[157]

Bishop Elder spent the rest of the war serving his diocese, Union and
Confederate, black and white. His primary responsibility, as he saw it, was
to save souls, and all souls were worth saving. The bishop earned the respect
of soldiers and generals, slaves and free. He never received compensation
for the church buildings destroyed in Jackson, but his fiscal concerns paled
when compared to the trauma his state and diocese would experience in the
postwar decade. The pastor and his sheep "were entering a period in the
history of the South which was to be more troubled and tragic than the war
years had ever been."[158]

A BARBECUE BECOMES A CONFLAGRATION

On Saturday, September 4, 1875, the Republican Party held an open
gathering and barbecue in Clinton. Somewhere between 1,000 and 1,200
blacks attended, with a sizable minority armed with pistols. From 60 to 70
whites also attended, of whom a good number were also armed.

The fate of four men—two rich and two poor, two black and two white—
would be sealed at that barbecue. That day, one would be disemboweled.
The next day, another would be decomposing in a swamp. Four months
later, another would receive an assassin's bullet in the back of the head. The
fourth would end nearly a decade of public service in disgrace.

According to an investigation begun that day and concluded more than
a week later by the Democratic-Conservative Executive Committee, the
Clinton Riot began when a white man and a black man started arguing.
The disagreement escalated and a gun was drawn. Most sources, black and
white, say the gun was drawn by Frank Thompson, a white lawyer who was

hoping to be appointed district attorney by Governor Adelbert Ames but had taken heavily to whiskey in his frustration.

Thompson was said to have then fired the gun, perhaps at an antagonist, perhaps accidentally into the ground. Other guns were immediately drawn, and sporadic firing commenced. Another white man, Jesse Wharton, fell dead at the spot, and his fellow whites began to flee with the black crowd in pursuit (one witness, a nineteen-year-old black man named Henry Jackson, claimed that it had been another black man, Louis Hargrove, who first died on that fateful field[159]). By the time the firing stopped moments later, two black men had been killed and four wounded. The white Democrats had suffered three deaths and four wounded.[160]

Earlier that day, Square Hodge tied his shoelaces and walked out the front door of his house. He lived with his eighteen-year-old wife, Ann, and two children about eight miles south of Raymond. He and his brother-in-law, John Jones, who lived with Square and Ann Hodge, were on their way to Clinton to attend a political rally and eat some barbecue. It would be the last meal the two young black men would share together.[161]

Martin Sively and his cousin Andrew arrived at the barbecue after a short journey from their neighborhood halfway between Raymond and Clinton. An old friend of the white cousins, a black man named D.C. Crawford who used to play with them by the creek near their house, greeted Martin, but Martin looked "grum" and wouldn't respond.[162]

The two cousins were close. They had grown up together, played together, raised hell together and gone to jail together. Not long before, they had spent the night together in the Clinton jail. Martin had parked his horse illegally while he, Andrew and friends held court in the nearby saloon. Meanwhile, E.C. Welborne, the black constable, had been ordered by Clinton's mayor to "arrest" the horse. He had been in the process of doing so when Martin had emerged from the saloon, gun drawn. He had demanded that Welborne immediately release his horse. Andrew and other Sively friends had also drawn their guns in support of Martin.

Welborne had seen the mayor at the end of the street watching. Between glances at Sively's pistol and the mayor, he had ascertained that four or five men were on their way, pistols drawn, to his aid, having been sent by the mayor. Welborne had leaped behind the horse, declaring that he would not release the animal. The good samaritans had arrived, and the Sively crew had been surrounded and arrested.

The Sivelys had been fined twenty-five dollars each, whereupon Martin swore he would exact revenge by killing the constable.

But now all that was past. Welborne and Martin had moved on. In fact, Martin was working as a deputy for a Republican sheriff in Raymond when Welborne had conducted some business in his office. Business was handled amiably, and the "arrested horse" incident seemed to be in the past. Now the cousins were in Clinton, whiskey in tow, to attend a political rally. They were ready to enjoy themselves.[163]

The bullet whizzed by Senator Caldwell, who, in turn, drew his own gun and shot his assailant dead. It was the first time a black man had shot a white man in Hinds County.

The senator was arrested, but when it was proven that he had acted in self-defense and that the other man had fired first, Caldwell was acquitted. But now he was a marked man. Black men didn't serve in the state legislature without arousing the enmity of white Democrats. They didn't pass laws extending the vote to black men, integrating the schools and legalizing interracial marriages without consequences. And they certainly didn't gun down white men in the streets without lethal retaliation.[164]

On September 4, Caldwell arrived at the barbecue that he had helped organize. He had invited a Democrat to speak before the keynote Republican speaker. The Democrat spoke for about an hour, and Caldwell was pleased that things were moving along. Then he heard the pistol shots.

Adelbert Ames was serving his fourth year as governor of Mississippi (1868–70, 1874–76), and perhaps his greatest test had arrived. Just nine

months before, a race riot had erupted in Vicksburg that left thirty-one people dead. Now it appeared as if another, greater riot was about to erupt.

Ames had been invited to the Clinton barbecue and was expected to deliver a speech. However, other matters had demanded his attention, and he had decided to stay in Jackson. It would become a fateful decision.

That night, reports began to come into Jackson telling of a general massacre in which armed blacks attacked, butchered and mutilated innocent white citizens. Then more reports came in telling of the white retaliation and the murder of countless innocent blacks by white vigilantes. The governor was facing what he feared most: the beginnings of a race war.

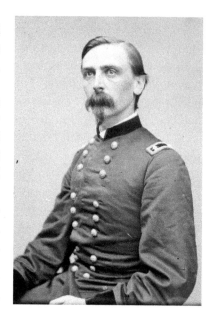

Adelbert Ames. *Library of Congress.*

According to the mayor of Clinton at the time, G.M. Lewis, he himself had telegraphed the threat of a race riot to Vicksburg and Jackson. He intimated that armed blacks were marching on the city and that Clinton's white citizens would be at their mercy; 60 white men from Jackson and 125 from Vicksburg soon arrived in Clinton. Lewis admitted that there had been several unauthorized killings of blacks on Saturday night and a few more on Sunday morning but stressed that the end result had been peace in the streets of Clinton by Monday morning.[165] He sent the impromptu militia home with the exception of 20 men whom he asked to remain behind for protection.

Over the course of the next week, somewhere between thirty and fifty black Mississippians would be buried, victims of white retaliation for the "massacre" of white citizens.[166]

Square Hodge came running into his house with his arm bleeding. He told his wife, Ann, that he had been shot, and he wrapped his arm up in a sling.

The next morning, several white vigilantes broke into his home. At pistol point, Square's brother-in-law, John, revealed Square's hiding place. The posse found him, called him a "damn son of a bitch" and ordered him to follow them outside. Ann tried to tie his shoes for him on account of his broken arm but was so distraught that she couldn't get them tied quickly enough—nor well enough.

"Let the God-damned shoes be; he don't need any shoes," said a man named Quick, one of the vigilantes and an acquaintance of the Hodges'. They then took Square outside with them and led him away.

One week later, a black man who had been fleeing the vigilante justice of the Democrats reported finding Square's body in a swamp. The same Mr. Quick who had been part of the posse that dragged Square away lent Ann a wagon and built a box in which to put Square.

They soon found Square. As Ann later testified, "The buzzards had eat the entrails; but from the body down here [indicating] it was as natural as ever. His shoes were tied just as I had tied them."[167]

The twenty-two-year-old was running for his life, pistol in hand. A mob of black Republicans pursued him and his friend Walter Bracey. When flight seemed futile, Martin Sively turned around to surrender his emptied pistol to his nearest pursuer, who took the gun and swung it at his head, knocking him down. Martin got up and continued his flight with Bracey. Again, he was caught from behind. This time, Bracey kept on running. As he fled, Bracey looked over his shoulder and saw about a dozen black men gather around the fallen Martin. Bracey continued his sprint to Clinton, trying to outdistance the sounds of Martin being pummeled.[168]

According to eyewitness testimony, Martin had either been in the wrong place at the wrong time or he had gotten what had been coming to him. He had been, to some, a quiet man, "well known and liked" in his neighborhood;[169] the "son of an old and highly-respected planter" with an "estimable character";[170] and a man who, though a bit wild in his youth, had become a respectable citizen[171] who had not taken a drink of alcohol in three years.[172] To others, he had been an "uncompromising Democrat";[173] a member of a violent committee intent on disrupting the democratic process wherever black Republicans threatened to exercise their political rights;[174] and the man who had fired the first shot at the Clinton Riot.[175]

Andrew Sively found the body of his cousin Martin about a quarter of a mile from the shootout. Martin's body had several pistol wounds and a knife wound that had opened his stomach. There were more club blows around his head, and his ring finger had been pulled off.

Not far from Martin lay Frank Thompson, the man who had first drawn his pistol in the crowd. He had been shot in the thigh and over the left eye. His skull had also been smashed, and there was a gash across his neck.[176]

Word quickly spread that blacks had begun a general massacre of white citizens in Clinton.

On Christmas Day 1875, three and a half months after the Clinton Riot, Senator Charles Caldwell arrived at Chilton's store. He planned to have some Christmas cheer with his friend Buck Cabell, a white man who hadn't joined the white vigilantes and paramilitary groups roaming the countryside.

The two walked inside, poured their drinks and toasted. At the sound of clinking glasses, a pistol shot rang out, and Caldwell fell forward with a bullet in the back of his head.

Not long after, Caldwell's wife, Ann Margaret, made her way to Chilton's store. She stepped over a dead body in the street on her way into town, but because of the darkness, she could not tell who it was. When she got to the store, a number of white men with guns refused her entrance, saying she better get out of town or they would make it "very damned hot" for her. Ann Margaret returned home, passing the dead body on the street again. She went up to her room and "laid down a widow." Later that night, Preacher Nelson showed up and informed her that her husband had indeed been assassinated and that the body she had stepped over had been that of her husband's brother, Sam Caldwell. Sam's wife and three children were staying with Ann Margaret when she found out.

Preacher Nelson went on to tell Ann Margaret that her husband had lived for a brief while after being shot. He called out to his friends at the store, but none stepped forward to help him. He begged to be taken outside so he could die in the open air—this request they obliged. They carried him into the middle of the street, but he was by then as good as dead. Then, what had become a mob opened fired on him, riddling his body with thirty or forty pistol balls.

Ann Margaret dressed the bodies of her husband and brother-in-law as best she could. Later that night, a number of white men from Vicksburg forced their way into her house and began taunting the dead Caldwells to rise and fight them.[177]

About one month after the Clinton Riot, and two months before Caldwell was assassinated, Governor Ames sent five companies of black militia and two white companies to deliver some weapons to another state militia unit at Edwards' Depot, about twenty-five miles from Jackson. He placed Senator Charles Caldwell in charge of the companies.[178]

Without a doubt, Caldwell was a brave man, a man who was prepared to fight if a fight came his way, as evidenced by his gunning down a white assailant in Clinton. But he was also a man with a level head. During the riot at the barbecue, it appears from the testimony of several eyewitnesses—though others dispute it—that Charles Caldwell was neither a provocateur nor armed. Instead, he seems to have been a voice of reason, trying in vain to keep the peace. Hubbard Strange, a forty-year-old black witness from Hinds County, insisted that Caldwell had not been armed. Morris Ward, a white Democrat, confirmed Strange's testimony when he swore:

> *I will state that just before the firing commenced I said to Charles Caldwell, Sr., who was not more than a few steps from the party of white men I have already described, that he must, for God's sake, stop this fuss; I heard him say, "I am trying to stop it"; I am sure Caldwell tried his best to stop the difficulty and keep the peace; I can say Caldwell did not participate in the fight.[179]*

Nevertheless, Caldwell was a leader of men and had the complete trust of Ames. His wife, Ann Margaret, would later claim that accepting this mission is what led to his Christmas Day death. She testified, "They killed him because he carried the militia to Edwards', and they meant to kill him for that. The time the guns were sent there he was captain under Governor Ames, and they said they killed him for that; for obeying Governor Ames."[180]

Caldwell led his uniformed and armed black troops from Jackson to Edwards. He delivered the weapons and then began the return trip. The sight of three hundred armed black men, just a month after three white men had been killed by a group of blacks, terrified the citizens of Clinton.

On October 9, 1875, General J.Z. George received a telegram from William A. Montgomery: "We learn that Caldwell, with one hundred armed men, are marching upon our town. What shall we do—submit or resist? We are able to do either. Answer immediately."[181]

R.L. Saunders was in Jackson when a telegram arrived referencing the black militia in Clinton. He gathered seventy-five men and boarded a train to Clinton. Within one mile of Jackson, the train was fired on. Three miles outside Clinton, the tracks had been torn up. Throughout the ride, Saunders wondered why the black militia had not been sent to Edwards' Depot by train. Instead, they had been sent by foot on a sixty-mile round-trip journey. Saunders was certain that Ames had sent them by land to purposely antagonize and frighten the white citizens along the way. He relayed to the House investigating committee, "The feeling among the whites was unkind toward Ames, because they regarded him arming these negroes as a menace to the white people, and calculated to bring on a disturbance, in which even women and children would not be safe."[182]

Saunders testified that a riot was prevented only by the restraint and prudence of the white citizens. He said that J.Z. George had urged the citizens of Clinton to stand down and allow the five black companies to pass unmolested.[183]

Marion Smith echoed Saunders's testimony when he claimed that whites urged one another all along the route to keep the peace if at all possible. Only the restraint of whites, according to Smith, had prevented bloodshed.[184] Never mind that the uniformed soldiers were on official duty. Never mind that they were the black half of Mississippi's only defense against white vigilante and paramilitary groups that were harassing the countryside. And never mind that it had been their own people who had suffered nearly a twenty-to-one casualty rate during the last two race riots. What mattered was that they were black men marching in the presence of white citizens, armed with guns.

On January 7, 1876, the Mississippi House of Representatives decided to launch an official investigation into Governor Adelbert Ames, expecting to find him guilty of high crimes and misdemeanors against the State of Mississippi.[185]

The House concluded its investigation and filed its majority report on February 22. The report claimed that the committee had worked three to

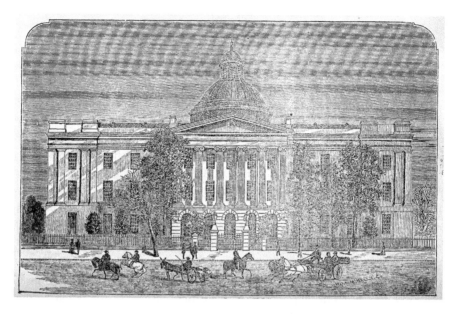

The Old Capitol in 1885. *Library of Congress.*

five hours a day for thirty-eight days, during which time it interviewed fifty-five witnesses—thirty-six Republicans and nineteen Democrats. It concluded that impeachment was necessary.[186]

Ames was accused of committing eleven impeachable offenses. The most damning was the eleventh: he was accused of arming the Hinds County militia in September and October 1875 in a time of peace and especially for sending Charles Caldwell's company, composed of black men, to Edwards' Depot. The company was officered in part by and composed of black men known to have participated in the Clinton Riot. Ames, according to the impeachment report, had encouraged and caused them, armed and defiant, to parade the streets of Clinton with the deliberate intent to create a disturbance and plunge the country into a war of races, with all its attendant horrors.[187]

The House also held Ames responsible for the riot in Vicksburg on December 7, 1874, that left two whites and twenty-nine blacks dead. Ames, according to the majority report, "would have been responsible for a greater loss of life in Hinds County in the fall of 1875, but for the timely interference of prudent and discreet persons to prevent the same."[188]

Ames made a deal and agreed to resign the governorship.

Adelbert Ames led the state of Mississippi during an exceptional time in its history—exceptional because the state was recovering from civil war and for the amount (and kind) of interaction between black and white Mississippians. Slavery had preceded Ames's governorship, and Jim Crow repression followed it. But for a brief window in between, black Mississippians could be senators, march armed through Jackson's streets, drink with white friends in saloons and attend mixed-race barbecues.[189]

By 1890, segregation had become ensconced in Mississippi. Black citizens were excluded from mixing with whites in saloons, restaurants, parks, public halls and cemeteries. Mississippi pioneered new means of disenfranchising them at the voting booth, adding poll taxes and literacy tests as prerequisites for voting.[190]

In 1867, the total number of registered voters in Mississippi numbered 137,000—58 percent were black. Several black men served as legislators, and one was even elected lieutenant governor.[191] In 1890, 67 percent of black Mississippians were registered to vote. Two years later, that number had plummeted to 5.7 percent. That number stayed the same until 1964.[192]

A FEVER FALLS ON JACKSON

It's a hot summer day in 1878. A middle-aged black man poses for a camera in front of the Mississippi capitol building. He is told not to smile and to hold his pose for twenty seconds. He stares straight ahead, mouth closed. Nearly half a minute later, he is given permission to stand at ease. He swats at a mosquito on the back of his hand. He has swatted at many mosquitoes this day. This one, he gets. He knows because a red-and-black smudge appears on the back of his hand. He brushes it off onto his trousers and forgets about it.

Four days later, he wakes with a harsh headache. His back hurts, too. He hasn't stayed up late. He didn't consume any whiskey the night before. He didn't overexert himself in the fields the day before. But damned if this wasn't the worst hangover and backache he has ever experienced.

His wife makes some corn pone, but even the smell of his favorite food nauseates him. He has no appetite. Instead, he rolls over and vomits.

Twelve hours later, he is fine. Twelve hours after that, he has regressed. The aches in his back and head return, along with a general body cramp.

Unbeknownst to him, his liver and kidneys begin to shut down. His skin is jaundiced. He gets up and stumbles outside to relieve himself. His urine is a very dark yellow. *Okay, I must be dehydrated. Nothin' water can't fix.* He drinks a glass of water and immediately throws it up.

Later that night, after a delirious sleep that isn't sleep, he wakes with a severe pain in his stomach. He vomits again and rolls over, trying to swipe away the residue of the discharge on the back of his hand; his hand has a dark-red stain on it. His wife notices his whiskey-bloodshot eyes. And then they, too, begin to bleed.[193]

Although this scene is imagined, the character's experience is typical of what befell sufferers of yellow fever in Jackson and other places in the southern United States in 1878.

The Yellow Fever Epidemic of 1878 killed more than 18,000 Americans. The two major metropolises near Jackson, New Orleans and Memphis, reported 3,929 deaths (out of 13,083 cases) and somewhere between 5,000 and 6,000 deaths, respectively. Jackson by contrast suffered only 69 deaths out of 428 cases. However, these low fatality numbers are deceiving.[194]

On August 18, 1878, the city of Vicksburg, about forty miles to the west of Jackson and located on the much-traveled Mississippi River, reported one hundred cases of yellow fever. Jacksonians began to fear the worst. Three days later, a full panic hit the city. As of August 21, no cases had been reported in Jackson, but the proximity of Vicksburg, as well as cases in Canton, roughly twenty-five miles to the north, convinced the citizens of the capital that the time had come to seek refuge. Half of the city's population of six thousand fled to the countryside. Three quarters of the white population was gone overnight.[195]

On August 24, rail travel to both Vicksburg to the west and Meridian to the east was shut down. The city was officially quarantined. Detectives and investigators roamed the streets searching for cases of the fever as well as non-locals who had entered the city despite the quarantine. A close-of-August report from New Orleans cited 3,111 cases and 915 deaths in the Crescent City less than two hundred miles south, inciting more precautionary hysterics.[196] The first death in Jackson occurred on August 31, and the quarantine tightened.[197]

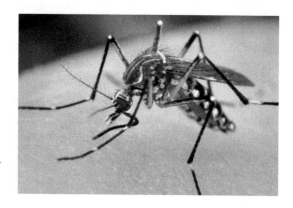

Aedes aegypti, the mosquito responsible for spreading yellow fever. *Centers for Disease Control and Prevention.*

While three-quarters of the white population had already fled the capital, most black residents were stuck inside the city. Many had neither the means nor the connections to flee. Others were forced to remain by means of a "double quarantine." There was a great fear of "idle blacks" before the scare, and that fear extended to the spread of disease. Thus, fearful whites began to patrol the country roads to keep the black residents of Jackson from spreading the disease to the countryside. At the same time, both whites and blacks who had remained behind in Jackson kept the rural blacks from potentially bringing the disease into the city.[198]

By the end of October, the fear of yellow fever had begun to dissipate in the capital. The Vicksburg-Jackson-Meridian rail line was reopened. The total death toll of 69 out of 6,000 total inhabitants was only about 1 percent of Jackson's population, or 2 percent of who remained behind. Yet roughly 7 percent of the citizens, or 15 percent who stayed in the city, were infected by the fever. Just twenty-five miles north, Canton (population 2,000) suffered 1,100 cases of the fever and 150 deaths, or a 55 percent infection rate and 7.5 percent fatality rate.[199]

Unfortunately, the 1878 epidemic was not the state's first, nor its last, battle with yellow fever.

Jackson had first battled a large-scale outbreak of yellow fever in 1872.

In 1870, Bishop William Henry Elder, who had walked the streets of a ruined Jackson five years before, was away in Rome attending the First Vatican Council. He had left Father Francis Xavier Leray in charge in Vicksburg. It was the same Father Leray who had led his congregation after

the burning of St. Peter's, the Catholic church in Jackson, and who had prematurely made his will before saying mass in the hospital chapel during a Yankee bombardment.

On September 1, 1870, Father Leray sent Sisters Mary Vincent Browne, Mary Rose Stevens, Mary Alphonsus Hooey, Mary Aloysius Houk and Mary Magdalen Keller to Jackson with the intent of establishing a school in the capital city.[200]

When Bishop Elder returned in 1871, he was pleased with the progress made at the Jackson school. He brought Sister Mary Angela with him and established her as the head of the new school built in honor of Saint Joseph.[201] He put $1,000 down on the property and commissioned the nuns to teach the poor children of Jackson.[202]

The local priest, Father Henry Picherit, held a fundraiser for construction of the new school and a convent to house the nun-teachers. The local Jacksonians raised $2,000, and Father Picherit went to sleep that evening with plans to deposit the generous donations at the bank in the morning. But that night, robbers broke into the rectory and stole all the funds.[203] Crestfallen, Father Picherit took another two to three years constructing the necessary buildings to relieve the overcrowding.

And then yellow fever struck. The school was forced to close for six months when the epidemic of 1872 hit Jackson.[204]

In 1878, while those with means were able to flee the cities at the first rumors of plague, those who stayed were equally susceptible to its ravages. Mother Mary Bernard wrote:

> *There was not a household that did not mourn one or two loved ones who had fallen victim to the plague. The first Sunday they had assembled for holy Mass the scene in the Church was pathetic; every pew held more than one black-robed figure and when the "Kyrie eleison" sounded, a pitiful wail of grief mingled with the words.*[205]

Other priests in Elder's diocese—which included Jackson, Natchez, Vicksburg and the Delta—fell victim: Fathers Mouton, McManus, Van Queckelberge, Cogan, Oberti and Vitolo all contracted the fever. "Sisters of many orders, going through the wards among the sick and the dying, fell

THE WORLD WONDER

DR. CONDORY'S

AQUA TERRA!

A SPEEDY AND SAFE HELP FOR
SUFFERERS FROM

YELLOW FEVER.

An advertisement published in Vicksburg during the yellow fever years. *Library of Congress.*

victims to the foul blow of the scourge," one historian wrote. "Congregations were decimated."[206]

Even Bishop Elder was struck with the fever. His condition quickly deteriorated to the point of having last rites administered in preparation for his imminent death. The sacrament was administered by Father Picherit, who had avoided the quarantine by being smuggled to his bishop under a pile of wooden sticks by two Catholic railway men. When Father Picherit arrived, he found Fathers Vital and McManus dying and the bishop in critical condition. He wasted no time ordering burial vestments from the cathedral in Natchez. Fortunately, the fever broke in the bishop, and within days, he was reading his own obituary in the newspaper on his way to a full recovery.[207]

When Bishop Elder recovered enough to resume his ecclesiastical duties, he determined to send five of the Sisters of Mercy east. Three would go to Meridian and two to Jackson. Ideally, he hoped they would fulfill their vocations as teachers. But given the fluctuating nature of health at the time

and the versatility of the sisters, their vocations could change at the bite of a mosquito.

The plan was to send the five sisters from Vicksburg to Meridian by train. Then Sisters Mary Camillus, Mary Bernard and Mary Stanislaus would open a convent in Meridian. Sisters Mary Hooey and Mary Vincent would double back to Jackson. As the sisters prepared for their new assignment, the epidemic of 1878 was in full swing. The town of Meridian voted to establish a shotgun quarantine and forbade any visitors from entering their city. The city wired the rail company with their decision.

The five sisters were sitting in their seats when, ten miles into the journey, the conductor ordered their luggage to be thrown off the train near a town named Bovina. He then approached the sisters and said, "Your trunks are off the train; you must get off too; I cannot take you sisters to Meridian." Sister Mary Vincent argued that they had already paid their fare, and they expected their tickets to be honored. When the conductor told her he had orders to avoid Meridian, she asked him to get her as close as possible to that city. He gave her a timetable, which Sister Mary Vincent looked over before saying cheerily, "I'll get off at Chunky; it has a comfortable sound."

As the train neared Chunky, sixteen miles from Meridian, the baggage man who had thrown their baggage off at Bovina prepared to toss them off again, this time for good. The train slowed enough for the sisters to dismount and then sped off again.

The five nuns stood in a strange and lonely woods near midnight, miles from their destination. Frightened and anxious, they sat down on their trunks, enjoyed a meal at Sister Mary Vincent's insistence and then began to pray their rosaries.

While the quarantine was being discussed by the citizens of Meridian, Father Louis Vally, of the same city, organized a number of Catholics in the area, and they made plans to pick the sisters up wherever they would be dropped off and bring them to the outskirts of the city.

After zigzagging through the woods for thirteen miles, four Catholic laymen finally located the sisters. "Are the sisters there?" one whispered from the forest. The nuns joyfully affirmed their identities, and then two wagons pulled up to take them to a house just outside the city where they would wait until they were allowed to enter Meridian.

The next morning, Father Vally rode out to greet the sisters and bring them some articles to make their stay more tolerable. A citizen of Meridian saw the priest leave the quarantine and return. Father Vally was turned in to the authorities and given twenty minutes to get out of town.[208]

The fear of yellow fever spread all the way north to Minnesota. Luther Manship received a letter from his brother, Charles Henry Manship Jr. of Minnesota, in 1879:

> *I am glad to see that in all probability you will not be troubled with the fever this year. Your fear that it would break up your business and blast your bright prospects—I am happy to see, and believe, will not be realized. New Orleans has fortunately escaped—so far—and as a consequence those towns dealing largely with her will also be free from fever. It is always the case that N.O. infects the towns north of it on the N.O.J. & NRR.*

That same year, Charles Jr. would bring his family to Jackson to celebrate the wedding of two of his sisters.[209]

Eventually, the epidemic of 1878 would pass, as all epidemics do. Yet the fear of yellow fever would be a yearly worry in Mississippi until the disease was finally brought under control after the 1905 outbreak in New Orleans.

Part III

A CITY IN FLUX, 1890s–1940s

WHISKEY BENT AND JACKSON BOUND: THE SAGA OF THE DECELL FAMILY

The winter of 1893 must have seemed never-ending to Kate Decell. Misfortune kept piling up on the woman, and the source of that misfortune seemed ever to be her husband, T.F. Decell. The man was addicted to alcohol, in debt, violent and—as Kate was beginning to realize—in the process of robbing her of a small fortune.[210]

Kate had grown up in Jackson, a member of the "old and highly respectable" Rutherford family.[211] But her marriage to T.F. had taken her fifty miles north, to the young Delta town of Thornton, Mississippi. She was mostly isolated from her family there, but she did have a lifeline—her brother James "Shug" Rutherford, who lived and worked with the Decells in Thornton.

On a Tuesday night in March of that year, T.F.—his wallet flush with his wife's stolen money—arrived home drunk and belligerent after a night out in Yazoo City. Kate fled their house, seeking refuge in the family's chicken coop. T.F. followed her there and beat her savagely.

The next day, Shug, noticing that his sister had not appeared for breakfast or lunch, went to her bedroom to check on her. There he found her, beaten, bruised and bedridden. "Protect me," she said to him. "Get me out of here."

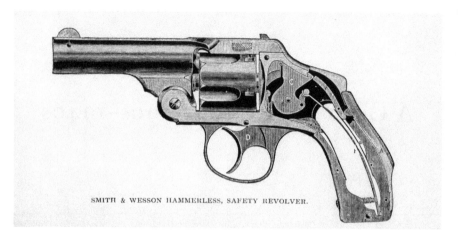

SMITH & WESSON HAMMERLESS, SAFETY REVOLVER.

Engraving of a .38 Smith & Wesson from the 1890s. *Library of Congress.*

Shug sent a telegram to another brother, Bob Rutherford, in Jackson. The following day, Bob arrived in Thornton. T.F. had left town on a train for Memphis, and the Rutherford brothers loaded their sister and her children into a buggy and drove them to the Rutherford family homestead on the outskirts of Jackson. Kate would later recall that she had "left" her husband. But T.F. would not let her go quietly; he arrived in Jackson a day later, learned that his wife had sought refuge in the city and announced his intentions of visiting her.

"The first thing he did was to tank up on liquor," an account of the day's events reported. "He was advised not to go…but he went, and the row which was predicted for him came to pass."[212]

As Kate recuperated from the beating, her two brothers watched over her, Smith & Wesson .38s in their pockets. At the same time, T.F. made his way through Jackson, north toward the Rutherford homestead, drinking whiskey and boasting to anyone who would listen that he would have his kids back even if someone had to die in the process. T.F. carried a gun that day, too—a .44 Colt, a long-barreled cowboy gun—and as he boasted, he rested his hand on its grip.

T.F. Decell and the Rutherford brothers would converge violently in Kate Decell's bedroom that night, but only two men would walk away from that room.[213] The story would shake the cities of Jackson and Yazoo City and make headlines across the nation.

Before it all fell apart, Kate and T.F.'s story was one of hope and second chances. They married in 1889, but both had been married before—Kate to a Jackson man named Dave Brown (and possibly to another man before that) and T.F. to a woman named Mary Scott.[214] Both their spouses had died, and both T.F. and Kate had children from their previous marriages (three for Kate and at least two for T.F.).[215]

T.F. was from Lincoln County, farther south, but when he and Kate married, they made their way northwest to the outskirts of Yazoo City. It was in Yazoo City that the Decells made the acquaintances of some rich and powerful members of the Delta gentry: Isaac Newton Gilruth and Chas C. Thornton.

Gilruth was a former Union soldier who had seen heavy fighting in Mississippi, Tennessee and Georgia during the war. He returned to Mississippi shortly after the war's end.[216] By 1875, he had established himself as a prominent Yazoo City merchant, selling dry goods, groceries and plantation supplies. He would grow fabulously rich, his company coming to own fourteen Delta plantations and a warehouse in Yazoo City.[217]

Thornton was a Baltimore-born medical doctor, professor, cotton entrepreneur, breeder of exotic livestock and socialite who had settled at a spot on the Yazoo River called Chew's Landing. A small town—named "Thornton" after the doctor—eventually grew out of the doctor's plantation. The doctor had big plans for his town; he wanted, among other things, to build an arbor there "to be used as a pleasure resort."[218]

Perhaps enticed by the doctor's optimism, the town of Thornton is where T.F. Decell and his family decided to settle around 1891, partnering with Isaac Newton Gilruth to open a store there. T.F. also produced and sold whiskey. At some point—perhaps years before—T.F. had grown to love the drink too much, becoming, according to one account, "addicted to strong drink" and acquiring a reputation, "while in his cups," as "a dangerous character."[219]

Not much is known of how well the Decells got along in Thornton, other than rumors printed in newspaper articles after the confrontation in Jackson; T.F. and Kate's marriage had never been a happy one, one article reported, and the beating of March 1893 had not been the first.[220]

What is known is that T.F. was required by contract to invest a certain amount in the business he owned with Gilruth—$500, or about $14,000 in today's dollars. It happened that his wife had recently come into a

sum more than triple that. Kate had owned a house and lot in Jackson—possibly an inheritance from her late husband—and in 1892 had sold the real estate for at least $1,600, or about $44,000 in today's dollars.[221] Kate deposited the $1,600 in a personal account in the Capital State Bank of Jackson. T.F. promptly visited the bank, forged her signature on a transfer slip and had the entire sum moved to his account at the Bank of Yazoo City.[222]

T.F. wrote a check for $500 to his business and withdrew the rest "for his individual use."[223] He lent $900 of it to his father, F.J. Decell (who testified later that Kate had been totally fine with her husband transferring the $1,600 to his personal account and that she was lying about the whole forgery part). How much of the remainder of the windfall was spent in the saloons of Yazoo City, Jackson and Memphis will never be known. What is known is that Kate found out about the forgery sometime that winter, and the betrayal led to the implosion of her and her husband's relationship.

When T.F. arrived at the Rutherford homestead late in the afternoon on Friday, March 17, Shug and Bob met him outside. Bob told T.F. that Kate had left him for good and that there would be no point in seeing her. T.F. could not be dissuaded, and the brothers allowed him to enter the house, asking him to sit in the front room while they spoke to their sister.[224]

In Kate's bedroom, the Rutherford brothers debated whether T.F. should be allowed to see their sister. T.F. made the decision for them, barging into the room unexpectedly. He spotted one of his kids, kissed the child and then saw Kate in bed and went to her. "Come here my darling husband," Kate said, touching T.F. It seemed her heart had softened some upon seeing him.

Bob and Shug stood watching the reunion, hands in their pockets gripping their .38s. "There she is, suffering from your bruises," Bob said.

"That's a damn lie," T.F. replied, drawing his .44 Colt.

Kate's aunt, who was also in the bedroom, grabbed T.F.'s arm in an attempt to stop him. T.F. told her to let go or he'd shoot her too. Then he raised the pistol at the brothers, firing twice. Bob was hit in the thigh. The brothers returned fire with their stubbier .38s, striking him several times in the abdomen and killing him almost instantly.[225]

A .44 Colt, the kind of gun T.F. Decell used in his battle with the Rutherford brothers. *Metropolitan Museum of Art.*

The day after the shooting, a jury examined the body of T.F. Decell and heard testimony from the many witnesses. The jury ruled the killing had been done in self-defense and acquitted the brothers.[226] Bob's wound was not thought to be serious.

T.F.'s parents and sister arrived that night to retrieve his body. They took the body back to Lincoln County, where it was buried the next day.[227] Although T.F. had been painted thoroughly as a villain by the media, his father continued to love his "beloved" son until his death in 1907.[228]

Later that year, a fire started in Decell and Gilruth's old store in Thornton, spreading to other buildings and eventually consuming the small town. The doctor's hopes of Thornton becoming a vacation destination went up with the smoke. The fire was said to have been caused by a defective chimney; it was as if T.F. Decell's malignant spirit were hanging around, hoping to cause just a little more havoc before departing.[229]

Kate stayed in Jackson, eventually settling in Fondren Village. The misfortunes that had poured down on her earlier in life seem to have dissipated some in the wake of her husband's death. Seven years later, she reported to census-takers that she lived in a house, which she owned outright, north of Jackson. She listed her occupation as "farmer" and shared the house with her five children, a son-in-law and one grandchild.[230] She lived in Jackson for at least another twenty years after that, ever carrying

the name of her dead husband—maybe out of custom, maybe out of love for the flawed man or maybe as a reminder of a woman's tenacity: *I'm still here…what happened to you?*

TIGERS, TEETOTALERS AND THE FIGHT FOR THE JACKSON SALOON

The night of June 4, 1895, was a sad one for Jackson's drinkers. Just a few weeks before, they had been able to revel in seven or eight different saloons. Then, with two hours to go before midnight and the onset of prohibition in Hinds County, they had one choice: Spengler and Muller's.[231]

Sensing that an era was over—for the time being, at least—a crowd of black and white men and women surrounded the East Capitol Street saloon on its last night of business. More than one hundred people crowded inside the bar, drinking its dwindling stock of alcohol (the only booze left at 10:00 p.m. was "stale keg beer," according to an account), while at least another hundred crowded around outside.[232]

The former location of Spengler and Muller's, Jackson's last saloon. *Josh Foreman.*

Prohibitionists had been fighting to make Jackson a dry city for nine years, and the night of June 4 marked their ultimate victory: the shuttering of the last saloon in the city. Newspapers reported the closing in spare, matter-of-fact terms. Jackson had become "dry as tinder," one reported.[233] "So far as saloons are concerned Jackson is dry as a 'powder horn,'" reported another.[234]

Jackson might have become technically dry, but the drinking culture was deeply ingrained in the city. Just months after carving Jackson out of the wilderness in 1822, the town already had three taverns.[235] One minister recalled the Jackson of the late 1870s: "Twenty-five saloons or more were dotted about the city where the keepers believed they could catch the unwary. Jackson was soaking wet and growing worse."[236] Although prohibitionists marked June 5 as a new, clear-headed starting point for the city, they would soon find out that reforming the city's hard-drinking ways was an impossible task.

Legal booze in Jackson was doomed from the moment the state of Mississippi began allowing counties to vote on whether to be wet or dry in 1886. Hinds County held a referendum immediately that year, and voters chose to adopt prohibition. Jackson saloons closed.

Then, in 1889, the county held another referendum (a referendum could be forced by a certain number of petition signatures), this time overturning prohibition. Saloons reopened.

In 1894, one year too late for the family of Kate Decell, yet another referendum was held. Voters chose prohibition, and this time it stuck. Results from the 1894 vote showed just how much Jacksonians, as opposed to Hinds Countians, wanted to keep legal alcohol; city residents voted two to one against prohibition but were outweighed by "small towns and country precincts," which voted unanimously for prohibition.[237]

Prohibition would prove to be an inconvenience, but not an impediment, for Jackson residents wanting to continue the party. The dreaded "blind tiger"—a word that could describe illegal bars, liquor or producers[238]—was known to prowl areas of Mississippi that had outlawed booze, and people knew well that the end of legal alcohol in the city could lead to the beginning of illegal alcohol.[239] Indeed, Jackson had already grappled with the problem of blind tigers a few years earlier when Hinds County voters had first voted to outlaw alcohol in the county.[240]

A Delta native, writing in 1970, recalled what the establishments were like: "A blind tiger was a…hut in the woods, a tumble-down shack on the edge of town. And don't think for a minute they sold 'white lightning' or white corn liquor only. They sold bonded whiskey straight from Old Kentuck."[241]

A letter written by the Anti-Saloon League appeared in the *Clarion-Ledger* three days after Spengler and Muller's closed. The letter is simultaneously gloating, optimistic, fearful and stern; the anonymous author compares the blind tiger to a "hydra-headed monster" whose appearance in Jackson would bring about "a state of affairs that would be too terrible to contemplate for a single moment." The author noted that he did not believe any blind tigers would emerge in Jackson and then went on to mention that it was being "whispered" that certain Jacksonians were planning to do just that.[242]

The letter's author did not have to wait long before seeing his hopes for a dry and law-abiding Jackson dashed to pieces. Blind tigers began operating immediately, and police undertook the task of stopping them. A newspaper account summarized the state of alcohol consumption in the city just weeks after legal drinking ceased: "Jackson is a prohibition town, but whisky is being sold boldly and drunken men are more frequently seen than before the saloons closed."[243]

A year after T.F. Decell met his whiskey-soaked end in his wife's bedroom, Jackson had become a dry town in letter but wetter than ever before in spirit—just the kind of place where Decell might have thrived if he had lived to see it. Within a few years, blind tigers had become a local institution. An 1897 report on the state of illegal alcohol in the city summed things up: "The blind tiger is numerous, and waxeth fat."[244]

As long as alcohol was legal in Jackson, men like Hubert Spengler and Anton Muller, who ran the last legal saloon in the city, operated with transparency, within the bounds of the law. Their petitions for license were published in the newspaper, they advertised and they were written about in society columns.[245]

The kind of men who took over the saloon business after it was outlawed were the opposite (Anton Muller included, it seems[246]); they were only written about when police caught them and then derisively. Just a month after prohibition took effect in Jackson, police began to crack down after observing that "whiskey was everywhere in strong evidence…men were

A prohibitionist cartoon. "The Father of (D)evils." *Library of Congress.*

staggering in every direction, evidences indisputable that the prohibition law was being violated boldly, if not openly."[247] They raided three bars in July 1895, at least one of which seemed to be operating in its old, previously legal location, as if prohibition had never passed.

The crackdown, led by an ever-wily Jackson policeman named James Ewing, drove alcohol peddlers "into the woods" and to the Pearl River.[248]

Individuals on both sides of the law achieved notoriety. Jesse Puckett was one such man, "one of the most notorious blind tigers who infest this city," one paper called him. He began selling illegal alcohol soon after prohibition passed and did so until his death at the hands of a customer in 1904. He was a massive man and a heavy drinker, and in addition to his blind tiger–keeping endeavors, he also ran illegal gambling operations. Puckett chose the Pearl River as the locale for his operation, crossing between Hinds and Rankin Counties and even operating a bar on a boat in the middle of the river.[249]

J.J. Baxter was a Jackson painter, aspiring politician and "excellent gentleman." He belonged to the temperance group the Order of Good Templars.[250] When the city was still issuing liquor licenses for new saloons, Baxter opposed the granting of such licenses "from a high moral standpoint."[251] He voted for prohibition. And he ran a blind tiger.

Before prohibition passed in Hinds County, Baxter had been arrested for selling whiskey without a license. He hadn't been *selling* whiskey, he told a jury, only giving bottles away to his friends. He continued peddling illegal whiskey after prohibition passed, getting busted several more times.[252] Somehow he was able to maintain his social status, helping police apprehend a "notorious negro outlaw" who had killed two policemen in 1898, the same year Baxter himself was busted for operating a blind tiger.[253]

James Ewing, who served at different times as a city marshal and as the chief of police, was another man who achieved fame with the rise of the blind tiger. Newspaper accounts treated him as a sort of detective-novel character—in one story after another, he outsmarted the bad guys with guile and trickery. In one, he overheard some soldiers talking about needing a drink; the soldiers gave away the name of a Jackson doctor who had been

dispensing "Jersey Lightning." Ewing visited the doctor, asked to be seen and promptly arrested him. In another story, he telegrammed New Orleans in search of incriminating federal tax records. He found the records and promptly arrested the men named in the records. He cracked another case by buying illegal liquor with a marked fifty-cent coin and then following the trail of the coin to the supplier of said liquor (and promptly arresting him).[254]

Methodist bishop Charles Galloway (the same who buried Charles and Adeline Manship) earned fame as the organizer of an interfaith and multiracial prohibition push in the 1880s. Galloway was outspoken about his desire for prohibition in Jackson and received threats from Jackson's saloon owners in return.[255] He came to earn the ire of Mississippi prohibitionists when he would not support a statewide statute banning alcohol, preferring instead to maintain the local referendum system established in 1886. When a campaign to make Madison County dry was begun, Galloway went there and spoke, too, but earned the ire of reporters when he called attention to violence whites had recently perpetrated against blacks and accused reporters of ignoring said violence. One reporter pronounced (without provided evidence) after the speech, "Bishop Galloway's address did the cause of Prohibition in this county more harm than good."[256]

Jackson's "saloon men," recalling the times when they could ply their trade legally, continued to push for another referendum on prohibition into the early 1900s. They filed petitions for local referendums in 1899, 1902 and 1903 but always seemed to come up just short of enough signatures to force a vote. The constant threat of legal alcohol with the result of a referendum was "a nuisance and a worry" to prohibitionists, and more and more sought to pass prohibition at the state level to end legal alcohol in Jackson once and for all. In the meantime, blind tigers flourished in the city.

"They were so bold and defiant that one was not surprised to find their presence almost anywhere," one prohibitionist wrote. "One was discovered running in full blast in the basement of the First Presbyterian Church in Jackson." One man was caught selling whiskey in front of the courthouse downtown.[257]

In 1908, prohibitionists won a statewide victory, settling the question of whether Jackson would ever have legal saloons again. The Mississippi legislature passed a statute outlawing saloons across the state.[258] Jackson's

saloon men gave up the hopes of collecting enough signatures to force one more referendum or campaigning to turn the minds of Hinds County voters just one more time.

THE GREATER UNIVERSITY THAT NEVER WAS

For a few weeks in 1928, it seemed as though Mississippi State and Ole Miss would be no more. Instead, the state would have only one major university: the Greater University of Mississippi. It would be the best-funded university in the South and have a state-of-the-art, $15 million campus. And that campus would sit in the middle of Jackson.[259]

Although talk of moving the University of Mississippi to Jackson began around 1900, the plan gained major momentum when Mississippi's newly elected governor, Theodore G. Bilbo, named it a priority in his inaugural address in January 1928.[260] The Greater University would give Mississippi a new sense of identity, he said, draw thousands of new residents from out of state and double the population of Jackson within ten years. The move would "do more to develop Mississippi and bring her the highest degree of progress and future glory than anything else."[261]

Plenty of Mississippians supported the governor's plan, including Ole Miss students by a margin of two to one, as well as many prominent Jacksonians.[262] Newspapers argued for it.[263] A state senator introduced a resolution the day after Bilbo's speech to enact the governor's plan.[264] But stripping Oxford and Starkville of their universities would prove harder done than said. Sentiment eventually won out, and the universities stayed in their respective towns—but for those two weeks in 1928, a vision of the Greater University took shape.

A 1931 profile in the *North American Review* provided a look at Theodore "The Man" Bilbo during his second term as Mississippi governor (he had first served from 1916 to 1919):

> *Built like a bantam-weight, Bilbo not only talks like a fighter, but looks as if he might have done fairly well with his fists in his younger days. Wherever he goes, the voters see a wiry little man with a pistol-butt scar down one*

cheek, a diamond horse-shoe stick-pin in a red necktie, an expensive but unpressed suit, and a pocket-full of cheap cigars.

On the stump Bilbo is a human autogyro. His stubby arms whirl constantly above his head, his deep voice alternatingly roars and idles, and he can lift his audience into fevered shouts one minute, dropping it gently on the brink of tears the next.

The profile colors Bilbo as a self-described "Mussolini" with few scruples and an irresistible appeal to rural Mississippians, who made up about 72 percent of the electorate at the time.[265] Bilbo referred to himself in speeches as a populist with only the interests of the people of Mississippi at heart.

In his inaugural address, he explained that while he would never want to do the people of Oxford "an injustice," he was obligated by his desire to serve the state to move the university: "In recommending the removal of the university, I have but one purpose in view. That is the best interest of all the people of the state."[266]

Historian David Sansing suggested that perhaps Bilbo was motivated by more than the people's best interest. Some in Mississippi's universities had been critical of Bilbo leading up to his election. Professors at Mississippi State (then called Mississippi Agricultural and Mechanical College) and Ole Miss had openly opposed him. In at least one case, Bilbo had asked Chancellor Alfred Hume of Ole Miss to reprimand a particular professor who had been fomenting opposition. Hume refused, and Bilbo became "embittered." Bilbo saw himself as a progressive and Ole Miss, as it existed in 1928, as an impediment to progress.[267]

Between his terms as governor, Bilbo had lived for a short time in Oxford—ten days, to be exact. He had been called to testify in a civil case and had refused. A judge held him in contempt and sentenced him to thirty days in the Oxford jail. He was reportedly brought meals three times a day by Chancellor Hume.[268] Whether the time the ex- and future governor spent in Oxford's jail contributed to his desire to move the university from the town is unclear.

Bilbo faced charges of "playing politics" with the state's universities. In a lengthy undated letter typed on "Mississippi Executive Department" letterhead, Bilbo blamed reporters for mischaracterizing him as anti-education and pointed to the recommendations of a University of Wisconsin professor named Michael V. O'Shea as the source of his desires for a Greater University. O'Shea had been tasked several years earlier with

Theodore Bilbo. *Library of Congress.*

examining the public education landscape in Mississippi and making a thorough report with recommendations.[269]

O'Shea was highly critical of Mississippi's universities in his report, writing that they were clinging to antiquated ideas about who should be educated and how. Mississippi's universities catered to "people who had leisure" and encouraged students to spend four years in "cloistral places," differentiating themselves from "their fellows of the shop, the factory, the farm, and the home." After earning degrees, graduates would float about their less educated peers in clouds of "awesomeness." Modern universities ought to teach more practical skills, O'Shea wrote, and be available to more people.[270]

Also included in the report was a recommendation almost exactly like the one Bilbo would eventually push in his inaugural address. O'Shea argued for the elimination of rivalries among the state universities and their consolidation into one educational institution. Bilbo even got the name for his vision from the O'Shea report: the "greater University of Mississippi."[271]

It seemed that Bilbo's desire to consolidate the universities was genuinely backed and even motivated by O'Shea's report. The report did not mention, however, establishing the Greater University in Jackson.

The most enthusiastic supporter of the Greater University of Mississippi vision may have been O.L. Bond, a publisher and editor from Wiggins, Mississippi, just a few miles down the road from Bilbo's beloved "native heath," Pearl River County. In a long editorial published two months before Bilbo publicly announced his support for the plan, Bond thought of what a Greater University would mean for the state.[272]

In his editorial, Bond seemed to harbor particular disdain for the town of Oxford. Oxford was a "remote and inaccessible spot far from the currents of life," he wrote, suitable only for "monastic" study. Bond echoed the populist tone found in the O'Shea report and Bilbo's speeches: "Today these seclusive and exclusive ideas about University education have passed away never to be revived. It is no longer a special privilege for the favored few but an absolute necessity for large numbers."

Bond lauded the founders of private Mississippi College, Belhaven College and Millsaps College for placing their universities in a central location and urged that the state follow suit with its public universities.

He included a detailed plan for how to move the University of Mississippi to Jackson—a plan that seemed to preview Bilbo's vision of two months later. Land formerly occupied by the state insane asylum should be appropriated for the university, Bond wrote. The university would occupy a total of one hundred acres in north-central Jackson. Only a few dorms would be built—after all, Bond wrote, "mature students manage their own affairs; and life in boarding houses, clubs and private homes is more normal." The university would house not only the professional schools for medicine and law but also the colleges of the liberal arts.

Bond concluded the editorial with a populist flourish: "The University is a state institution, it belongs to all the people of the state and vitally affects their welfare....The University of Mississippi is at the crossroads."

With a resolution to move Ole Miss introduced to the legislature and support for the idea mounting in Jackson, Chancellor Hume—who had once visited the governor in his Oxford jail cell—launched an all-out campaign to keep the university in Oxford. Two weeks after Bilbo's inaugural address, the Town of Oxford hired a train to bring the entire Mississippi legislature and its staff

from Jackson for a visit (Bilbo was unable to attend). In Oxford, the legislators were treated to lunch, a tour of the campus and the town and a five-hundred-person banquet.[273]

Hume was on hand to lobby the legislators, giving an "inspired address" that afternoon. A newspaper report named Hume's speech a turning point, noting that the chancellor had been able to evoke rousing applause from what had previously been a "hostile" legislature. In the speech, Hume relied on sentimentality, finishing with a rhetorical punch:

> *Gentlemen, you may move the University of Mississippi. You may move it to Jackson or anywhere else. You may uproot it from the hallowed ground on which it has stood for 80 years. You may take it from those surroundings that have become dear to the thousands who have gone from its doors. But, gentlemen, don't call it "Ole Miss."*[274]

The Oxford visit did seem to be a turning point for the Greater University. Within two weeks, the House of Representatives had passed a resolution proclaiming itself opposed to moving Ole Miss to Jackson—or anywhere else. The resolution passed 103 votes to 9, a lopsided result that had some wondering whether there had been some backroom dealing prior to the vote.[275]

The House of Representatives' resolution killed any possibility of the Greater University at Jackson, and Bilbo accepted defeat.[276] He did not allow Hume to enjoy his victory for long, however. Four months after the legislature's vote, Bilbo announced publicly that he would work to unseat Hume from the university's chancellorship.[277]

It took him three years, but he eventually forced Hume out of the position—along with upward of two hundred faculty and staff at Ole Miss, Mississippi State College for Women (Mississippi University for Women) and Mississippi A&M (Mississippi State University). Hume's ouster led to Bilbo being accused of implementing a "spoils system" in the state's universities and the suspension of accreditation for Ole Miss, Mississippi A&M, Mississippi State College for Women and the State Teachers College (University of Southern Mississippi) by the Southern Association of Colleges and Schools.[278]

Bilbo went on to be elected to three terms in the United States Senate but died in 1947 before beginning his third term. Three years later, the Mississippi legislature approved the establishment of a four-year public medical school in Jackson: the University of Mississippi Medical Center.

Jackson might not have become the home of a Greater University, but it did eventually get an important branch of the University of Mississippi.[279]

An amendment to the bill establishing the Medical Center was put forth suggesting that the center's teaching hospital be named for the late Bilbo. It was defeated by a vote of thirty-four to twelve.[280]

PILOTS AND POWS: WORLD WAR II ARRIVES IN JACKSON

The United States Army captured forty German generals during World War II. Thirty-five of them were sent to Camp Clinton just outside Jackson.[281]

The American government initially authorized the 790-acre camp to hold internal enemies. However, the number of said enemies was vastly overestimated, and Camp Clinton became a POW camp instead.[282] The first German prisoners arrived on December 17, 1943. Just a few weeks before, the camp supervisors had been anticipating Italian POWs, and all the signs had to be quickly changed to German.[283]

When the Germans arrived, most from the fighting in North Africa, the U.S. commander, Lieutenant General Brehon Somerwell, greeted them courteously and offered each soldier two packages of cigarettes.[284] Then the soldiers were ushered off to what would be their home for the next three years: twenty barracks surrounded by eight-foot-high double hog wire, topped by an additional two feet of barbed wire. Inside the double perimeter fence was a twenty-foot "dead zone" marked by yellow stakes. Should a prisoner wander into the dead zone, he could be shot from one of the guard towers equipped with searchlights, sirens and machine guns. In late 1943, twenty sentry towers were added, as well as dozens of pole-mounted floodlights that were turned on after dark. Finally, two trucks outfitted with lights and tear gas were available if needed.[285]

Other than the prison camp atmosphere, the German POWs were treated well. They received the same diet as their American counterparts—3,400 calories a day. A typical day included the following meals:

- breakfast: corn flakes, bread, marmalade, coffee, milk, sugar
- lunch: potato salad or boiled potatoes, roast pork or pork chops, carrots, water
- dinner: meatloaf, scrambled or boiled eggs, coffee, milk, bread

Ironically, corn, so abundant in America, did not factor into the German diet. Germans fed the starch to their pigs and refused to eat it themselves.

In addition to this daily diet, the prisoners were also allowed to buy sodas, candies and other snacks from the canteen.[286] Budweiser was also sold at fifteen cents a bottle and could be drunk from 5:00 p.m. to 9:00 p.m. Many soldiers opted to save their weekly pay and binge on Friday nights. Naturally, Fridays tended to be wild nights at Camp Clinton.[287]

While the food was abundant, the workdays were also relatively lax. The average day adhered to the following schedule:

- 6:00 a.m.: reveille
- 6:30 a.m.–7:00 a.m.: breakfast and break (or Mass for those who practiced)
- 8:00 a.m.: workday begins
- 12:00 p.m.–12:30 p.m.: lunch
- 12:30 p.m.–4:30 p.m.: work
- 4:30 p.m.–10:00 p.m.: free time (with dinner served between 6:00 p.m. and 7:00 p.m.)[288]

The soldiers spent their abundant free time watching movies (Deanna Durbin films were the camp favorites),[289] listening to music and playing ping pong, cards and chess. But the most popular recreational activity was undoubtedly playing sports. Soccer, volleyball, handball, tennis and boxing were particularly popular. The teams were broken into barracks, companies and compounds. There was even a senior division for the elder soldiers.[290] In 1944, 800 to 850 of the 2,400 prisoners played on either a soccer or a handball team.[291] The longest section of the prisoner-run camp newspaper, *Deutsch Insel (German Island)*, belonged to sports.[292] Camp Clinton also boasted a six-thousand-volume library[293] and provided arts and crafts activities as well.[294]

The relaxed conditions at Camp Clinton led to a relatively tranquil environment. During its three years of operation, the camp saw only four deaths. One soldier died of natural causes, and the other three died under questionable circumstances.

On August 6, 1945, Franz Pils was found dead with a cord wrapped tightly around his neck. According to the *Clarion-Ledger* account of the death, Pils had escaped several days earlier. The man became lost and decided to hang himself from a tree. He climbed into the tree, affixed a cord to his neck and jumped. The cord broke, but Pils died of strangulation nonetheless.[295]

One month earlier, on July 1, Major General Willibold Borrowtiz officially died of a cerebral hemorrhage. Unofficially, he stuck his finger into a light socket while bathing—another apparent suicide.[296]

Erich Ernst was also found dead in what seemed to be suicide by hanging. It was thus ruled. Rumors, however, spread that he had been murdered by a certain segment of the camp.[297]

Further proof of the general satisfaction with prison life is evidenced by the few escape attempts. Three such attempts, however, are notable.

On January 1, 1946, Hans Ortenstein and Herbert Schmidt left the camp and stole a jeep. Unfortunately, they wrecked their jeep at the intersection of Highway 80 and 51 near the Alamo Plaza and were apprehended when returning to the camp.[298]

In late 1943, six to eight POWs dug a tunnel three feet wide and one hundred feet long from their barracks. They got to within ten feet of the perimeter fence before their plot was uncovered. They had gotten so close to freedom by filling a hidden compartment inside their trousers with dirt and then dumping it when on work detail at the Mississippi River Basin Model. They were caught during a barracks inspection when a POW was found in bed with a field pack on.[299]

The most famous escape occurred when Lieutenant General Hermann B. Ramcke sawed through the bars of a storm drain beneath the Officers' Compound and made his way to Jackson, where he reportedly dined several times. His most eventful escape occurred on Christmas Day 1945, when he walked to Walgreen's with a one-dollar American bill in his pocket, ordered and ate a meal and then walked across the street to the Walthall Hotel and mailed a letter to Washington, D.C., complaining about the conditions for the German prisoners at Camp Clinton. Not wanting to return to camp before dark, Ramcke walked around Jackson until he felt it was safe to return. No one knew he had left the camp until D.C. contacted the camp demanding an explanation as to how an uncensored letter from Camp Clinton had reached them. The general refused to talk until he spent four days in solitary confinement at Camp Shelby on only bread and water. He confessed and was allowed to return to Camp Clinton.[300]

When the Second World War finally ended in an Allied victory in 1945, many of the German POWs were excited to return home—but not all of them. Word had gotten out that the Americans had discovered the concentration camps. Many Germans expected reprisals when they returned home. In addition, the USSR had taken over roughly half of Germany. Those POWs who lived on the eastern side of their homeland were understandably frightened.

Furthermore, a number of Mississippi planters and businessmen petitioned President Truman to delay the release of the prisoners. Mississippi, and the

nation as a whole, was in desperate need of manpower. Truman, therefore, delayed their release for another sixty days.

In July 1945, Camp Clinton held 3,000 prisoners. Four months later, in November, that number had shrunk to 1,100. In mid-March 1946, several hundred German POWs still remained at Camp Clinton. The final prisoners were not mustered out until March 31, 1946, when the camp officially closed down.

About one-fifth of the released Camp Clinton prisoners returned home. The others were sent to European POW camps, where they were forced to work in reconstructing the Europe their Führer had nearly destroyed. Some of these prisoners were still working in prison camps as late as July 1947.[301]

As thousands of German prisoners toiled in Clinton, another nation's citizens lived and trained in Jackson. They had been forced out of their own countries, the Netherlands and Indonesia, by the Germans and Japanese. A resolution by the City of Jackson illustrates the impact the people would come to have on Jackson:

CITY OF JACKSON, MISSISSIPPI U.S.A.
A RESOLUTION

Whereas,
The Royal Netherlands Military Flying School has been established in the city of Jackson, and
Whereas, the Netherlanders are our gallant Allies, and have honored our city with their presence, and in training at the Jackson Air Base, and
Whereas, the citizens of this City have the highest respect, regard, and sympathy for these noble people, and
Whereas, during the operation of this school, the following members have lost their lives: [the names of seventeen Dutch pilots who died while training in Jackson]
Whereas, it is a great sorrow and grief to the people as well as the Officials of the City of Jackson, NOW THEREFORE:
BE IT RESOLVED BY THE COUNCIL OF THE CITY OF JACKSON, MISSISSIPPI:

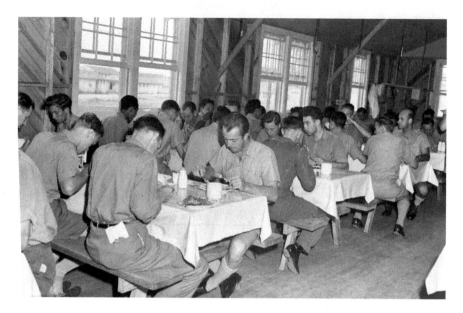

Dutch pilots dining in Jackson. *Dutch National Archives.*

> *That, as a small token of our esteem, and in remembrance of those men who have lost their lives in training here, we do hereby authorize the conveyance and dedication to*
> THE ROYAL NETHERLANDS MILITARY FLYING SCHOOL *of lots 47, 48, 49, 50, and 51 in Section Number 41 of Cedarlawn Cemetery*

[singed by the city clerk, mayor, and two commissioners][302]

In 1927, Charles Lindbergh, fresh off his transatlantic flight, spoke to the citizens of Jackson. He was so impressive and so influential that the citizens of Jackson approved the building of a new airfield. It was completed one year later and named Davis Field. Shortly after, its name was changed to Hawkins Field.[303]

Seven months later, Delta Airlines successfully completed its first ever passenger flight. The plane took off from Hawkins Field and five hours later landed in Dallas, Texas, on June 17, 1929.

Thirteen years later, the airfield made its greatest contribution to world history.

On May 8, 1942, a parade of military personnel marched down Capitol Street. "We never saw men in shorts before," one of the local spectators remarked.[304]

The Dutch, the majority of whom came from the Dutch East Indies—modern-day Indonesia—had arrived, dressed for the weather. They enjoyed the beginnings of a balmy, humid Mississippi summer. At the close of the year, they would be complaining about "the icy northern winds [that] often caused the temperature to drop tens of degrees in a couple of hours."[305]

The Dutch East Indies were overrun by the Japanese in early 1942. The Netherlands proper were in the hands of Adolf Hitler and Hermann Ramcke's Third Reich. The Dutch air force still existed, but without a home.

At first, the pilots trained in Australia. But due to limited facilities, and the Australians needing to use every bit of their own training grounds, the Dutch were forced to look at other options. They petitioned the War Department in Washington, D.C., asking for the use of a southern airfield.

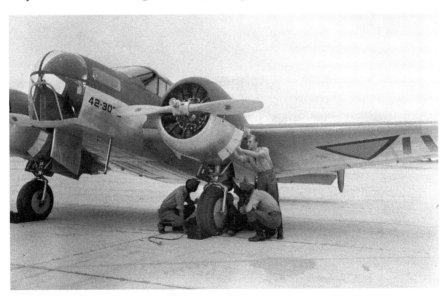

Dutch pilots working on a plane at Hawkins Field. *Dutch National Archives.*

In exchange, the Dutch government would provide Dutch instructors and Dutch planes and would pay the cost of training.

Eventually, the British, American and Dutch governments agreed to the proposal. By the time the base closed on February 8, 1944, Hawkins airfield was home to 155 Dutch officers, 232 noncommissioned officers, 188 soldiers and marines, 60 women, 57 children, 430 students, 60 instructors and 85 administrative officers and men. The base offered basic, advanced and operational training, as well as B-25 and P-40 training.

"The Netherlands were able to create a well-trained, though small, air force by early 1944." Hawkins Airfield sent a total of 233 pilots with advanced training and 178 with operational training to war against the Nazis and Japanese.[306]

On December 20, 1981, Carl McIntire of the *Clarion-Ledger* reported the discovery of parts of an airplane by Ronnie Virdern at the intersection of County Line Road and Livingston Road. Although there is no definitive proof, it does appear as if the plane belonged to J.F.H. Jansen, the twenty-two-year-old pilot who "plunged almost vertical to the earth" and crashed near that same field.[307]

A doting father stood over his newest and only child. His previous children had been killed when a Japanese plane hit the Dutch plane that carried his family from Java. Case Amsterdam and his wife suffered severe burns in the attack, and his children lost their lives. Now, in Jackson, Mississippi, the first Dutch baby of AAF's American venture was born on Mississippi soil to Case and his wife.[308]

He "looked down at the graves and told her, 'I want to be buried here.'"[309]

Captain Hermann J.A.C. Arens and his wife, Ans, visited Cedar Lawn Cemetery in Jackson. A number of his fellow Dutch pilots had been laid to rest in the cemetery more than sixty years before.

Monument to the Dutch pilots at Cedar Lawn Cemetery. *Caitlin Starrett.*

Arens had moved to West Virginia after the Second World War but always spoke fondly of his war years in Jackson. "We learned a lot in Jackson," he said. "They still had their great animosity against any color of skin other than white. Our group suffered with so many Indonesian born members."[310] Despite his observations on racial attitudes, Arens found the citizens of the capital accommodating and hospitable. It didn't surprise his family when he requested to be buried in Cedar Lawn. His daughter said, "It is fitting; he always spoke highly of Jackson."[311]

Yet immediately after his death, it looked as if Arens's final wish would not be fulfilled. The Dutch Embassy denied his request to be buried with his fellow Dutch pilots at Cedar Lawn. It insisted that those plots were solely for those who died in combat—or at least training for combat.

Ans Arens refused to accept this rebuff. She herself had spent three years as a POW in a Japanese camp, having been taken prisoner on her twenty-first birthday. When she was finally liberated, she had shrunk to one hundred pounds. Clearly, Arens still had some fight in her in her eighty-sixth year. She had a powerful ally in Lieutenant Colonel William Sanders of Jackson. Not only did Sanders vouch for Arens, but he also insisted that the city of Jackson remember the sacrifice of the Flying Dutchmen:

> *I've seen these cemeteries in Holland, Belgium and France (our boys are buried) are perfect. The people there take care of those cemeteries 365 days of the year. Surely we can look after this little plot for 365 days of the year. The nation doesn't need to lose interest. It needs to gain interest.*[312]

On Memorial Day 2007, Arens returned to Jackson to be buried. "He's home to Jackson, or to a piece of home, a part of his life he never forgot, to share his final rest with countrymen who were part of his youth."[313] One hundred people gathered around the small brown box at Arens's tombstone. Two Dutch flags blew in the breeze. Former Jackson mayor Kane Ditto spoke to the crowd, "They spoke a strange language and wore strange looking uniforms…but they forged a strong bond with the people of Jackson."[314]

On February 8, 1944, the Flying Dutchmen of Dixie bid the city of Jackson a fond farewell. Major General H.L. von Oyen and Jackson Mayor Walter Scott pledged everlasting friendship between the Dutch air force and the

city of Jackson. A *Jackson Daily News* article summed up the Dutch visit: "In turn, the friendly occupation by the Dutch enriched the daily life of your Mississippi capitol with their contributions of three royal visits, a new Christmas day, new music, new food dishes, hockey games;…and most important of all, they left you their dead."[315]

JACKSON COMES OF AGE, 1950s–PRESENT

JOSEPH BRUNINI, THE LIBERAL BISHOP

Joseph Brunini was born on July 24, 1909, to a Catholic father and a Jewish turned Catholic mother in Vicksburg. As the intelligent, athletic and charismatic Joseph aged, he began to be drawn toward the priesthood. While attending Georgetown University, he wrote home to his parents informing them of his decision:

> *I realize the difficulties I will face in returning to Mississippi as a priest, but what is the happiness of a lifetime to the happiness of eternity?....No one has tapped me on the shoulder and told me to be a priest, but I feel I am temperamentally fit for that life, and that I will be happy in it, that I can aid in the spread of the Church, and finally that there is not a single reason for not adopting the priestly life.*[316]

Later, while writing his memoirs, Brunini reflected, "The need for priests in Mississippi kept haunting me and I could not justify the thought of rejecting what I believed [was] God's invitation to the service of His Church and to my fellow Mississippians."[317]

The Catholic bishop at the time, Richard Gerow, was thrilled to have a native son, and a well-connected one at that, join the ranks of his clerics. He sent Brunini to study at the North American College in Rome. Although

Bishop Richard Gerow (*left*) and Bishop Joseph Brunini. *Catholic Diocese of Jackson.*

Brunini enjoyed his time in the Eternal City, he was homesick and eager to return to Mississippi as soon as possible.

Father Brunini finally returned home in 1937. The twenty-eight-year-old priest fulfilled the duties typical of a Catholic priest for the next twenty years. He said mass, heard innumerable confessions, taught Catechism classes and shepherded his flock. With each passing year, Father Brunini assumed more and more responsibility in the diocese. He very quickly became Bishop Gerow's most trusted cleric. When the chancery moved from Natchez to Jackson, Father Brunini was appointed pastor at St. Peter's, the new headquarters of the church in Mississippi.[318]

In 1954, the U.S. Supreme Court ruled unanimously in *Brown v. Board of Education* that the "separate but equal" doctrine that had provided the foundation for the South's segregated school system was unconstitutional. The ruling changed the state of Mississippi forever and greatly affected Father Brunini, who later reflected:

> *The full text of the Supreme Court's decision was printed in the* New York Times *and I was able to read it during the three-hour flight to*

Jackson. Naturally, as a Catholic priest and a citizen of Mississippi, I was deeply interested in social justice in all its forms. I was elated to see this reversal.[319]

From that moment onward, Brunini sought ways to integrate the diocese. He began by addressing the *Brown* decision at mass the following Sunday. He gave a homily praising the Supreme Court's decision. At the time, he was a regular parish priest, and in his audience that Sunday were the typical Catholic attendees. His homily was frowned upon by many. Brunini noted, "I could readily understand the puzzlement and the negative reactions as I chatted with some members of the congregation. So our Mississippi Catholics, along with the two million people living in the state, were launched on a long journey."[320]

Although Brunini had been heartened by the Supreme Court's 1954 decision, other Mississippi leaders saw it as the harbinger of a bleak future. Mississippi Circuit Court judge Tom Brady wrote a pamphlet shortly after the *Brown* decision entitled *Black Monday*, in which he predicted a deterioration of the seemingly calm race relations that had existed in Mississippi before the Supreme Court ruling. In an address made to the Indianola Citizens' Council on October 28, 1954, Judge Brady reviewed his pamphlet. He claimed that school integration would lead to miscegenation:

You can't put little boys and little girls together—negroes and whites, and have them sing together, and eat together out of the same pail, sit side by side, and walk arm in arm, and expect for the sensitivity of those white children not to be broken down. You can't do it. The old adage of "First we pity, then we pardon, then we embrace," applies.[321]

Judge Brady's address to the citizens of Indianola only summarized his *Black Monday* prophecies. In a pamphlet in which he likened black people to chimpanzees and argued that their social and mental development had been retarded, he also prophesied that this "monkey-race" would bring great violence upon the white community—and the *Brown* decision would hasten this violence, he argued. He predicted, "The fulminate which will discharge the blast will be the young negro schoolboy.…The supercilious, glib young

negro, who has sojourned in Chicago or New York, and who considers the counsel of his elders archaic, will perform an obscene act, or make an obscene remark, or a vile overture or an assault upon some white girl."[322] Judge Brady played off the greatest fear of his fellow white Mississippians: that desegregating the schools would lead to miscegenation.

A young Jackson lawyer and aspiring politician named Ross Barnett was similarly alarmed and began devising ways to subvert the *Brown* decision immediately after it was delivered. Just weeks after the decision, Barnett spoke at a meeting of the Mississippi Legal Education Advisory Committee and outlined the steps he thought the state should take in response. Black citizens should be encouraged to continue attending segregated schools, he told the committee, and further efforts should be made to "equalize" black and white schools. As a last resort, he said, public schools should be abolished altogether.

Less than a year after Brady, Barnett and other pro-segregation leaders had begun their fatalistic prophesying, the mutilated body of Emmett Till was thrown into the Tallahatchie River.

Brunini quickly became Bishop Gerow's right-hand man. It was no secret that he was being groomed to replace the aging bishop. And so Brunini began to learn firsthand the burden of shepherding such a large diocese, and he gained valuable experience in an administrative role. Brunini assisted Gerow and implemented the bishop's policies, but he also quickly began to put his own mark on the episcopacy. Brunini had been and remained a member of the Mississippi Council on Human Relations, a council that had been established in the 1930s to "improve race relations." In the 1950s, Brunini served as co-chairman of the Council of Interracial Cooperation.[323] These experiences with race relations would prove invaluable to his church as he took on more and more responsibility.

Brunini continued to work with Gerow's interracial and interfaith group. A diary entry on February 5, 1962, notes, "This morning I attended a meeting and luncheon at Tougaloo College along with the interracial group here in Jackson. We are trying to do what we can to improve race conditions in Mississippi."[324]

Two weeks later, his diary records another such interfaith and interracial meeting, this time a dinner party organized by the bishop. His dinner party

hosted twenty-two guests, among whom were Jews, Protestants, members of the Society of the Divine Word and Father Perry, the black rector at St. Augustine's, who gave the talk.[325]

Bishop Richard Gerow, along with with the assistance of his most trusted cleric, Joseph Brunini, began to reevaluate their own role in Mississippi's racial caste system. They declared that black Catholics were sons of the same Father as white Catholics and thus were to be treated so. Bishop Gerow even went so far as to threaten to place white parishes that refused to offer mass or the sacraments to black members under interdict—a most serious punishment in the Catholic Church, in which all sacraments are denied a parish until it repented and entered again into communion with the church's teaching. Although Bishop Gerow preached patience in bringing down the Jim Crow culture (and many do indeed accuse him of acting with an excess of patience), the bishop was simply looking to protect his black parishioners and at the same time ensure the continued attendance of his white congregants in an increasingly racist and violent society.

Historian Michael Namorato argued that Gerow's abhorrence of violence continued throughout his life, but his cautious approach was more seriously challenged by the early 1960s. There is no doubt that Gerow saw change coming. The *Brown* decision ending segregation in schools, the Meredith crisis at the University of Mississippi in 1962 and the Freedom Riders in Mississippi and Jackson itself all contributed to an atmosphere that Gerow described as tense. There is little doubt that the bishop saw the writing on the wall and was finally ready to commit his diocese to desegregation by the mid-1960s.

Despite their work with social activists on behalf of Mississippi's black citizens, Brunini and Gerow remained respected figures in the state. There are no accounts of death threats made against them or of the intimidation experienced by other socially active Mississippi ministers of the time. In fact, the bishop delivered the opening prayer at the Mississippi House of Representatives on March 12, 1962.[326]

Brunini was not the only Jacksonian acting on his conscience in the wake of the *Brown* decision. A young Jackson resident and *Times-Picayune* reporter named Bill Minor was developing a reputation for being a reporter unafraid to expose racial injustices. Minor's path would intersect with Brunini's in the turbulent '60s.

Minor had ensconced himself as a Jackson personality by 1954. He had already demonstrated that he was willing to speak his conscience on human rights issues; the previous year, he had spoken out about conditions at Parchman, the state prison farm. As the civil rights crisis in Mississippi grew, Minor began to dig into racial inequities. He compiled previously unknown statewide figures on black voter registration, exposed funding disparities between black and white schools and questioned secretive government practices.[327]

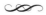

Joseph Brunini was ordained bishop of the Diocese of Natchez-Jackson in 1967. Two years later, on December 24, 1969, he delivered one of his most important speeches. He spoke at Christmas Eve mass and called for Christians and Jews to work together for racial reconciliation. In an article published in the *New York Times* the following day, Bill Minor introduced Bishop Brunini to the nation.

The sixty-year-old had only been bishop for two years and was thus relatively unknown nationally. Minor pointed out that Brunini had been harassed and abused by his fellow Mississippians in the '50s when it was revealed that he was a member of the pro-integrationist Southern Regional Council. Afterward, Brunini kept a lower profile through the tumultuous early and mid-'60s, when he was being groomed to replace Bishop Richard Gerow. According to Minor, it was not until the very end of the '60s that Brunini finally took a definitive stand for racial equality.

Nevertheless, Minor attempted to portray a kindly and sympathetic bishop who was a product of his times:

> *A mild, easy-to-approach figure, Bishop Brunini is neither imposing nor brilliant. Basically he is a Mississippian, because he feels great sympathy for his native state. To many situations, therefore, he responds conservatively, but he is not in a box and he can be swayed by liberal arguments.*[328]

He concluded his article by quoting Brunini himself: "Perhaps we have expected too much from our politicians. We as religious leaders can't blame politicians if we don't do our job first."[329]

Cathedral of St. Peter the Apostle. *Josh Foreman.*

Although Catholic elementary schools existed for black residents, there were no black Catholic high schools before 1966 and very few black enrollees until after 1970. Should a black Mississippian, such as a young Derek Singleton, wish to continue his education, he would have to leave the security of his parish school after grade six and make a fresh start by enrolling in the black public high school. Such a move could be challenging for the impressionable student who must now enter a new environment. To complicate matters, Catholics in Mississippi were an often looked-down-on minority in their own right. DeWitt Webster summed up the plight of black Catholics: "There was a saying in Mississippi that to be born a Catholic was bad; to be born a black was worse; but to be both black and Catholic was to really have the odds stacked against one."[330]

By January 1970, Bishop Brunini had made explicitly clear the church's stance on integration. He wrote a Pastoral Letter on January 2, to be read to all his parishes:

> *There should be no mistake concerning the Catholic Church's attitude towards school integration. Every Catholic school in Mississippi is obligated to admit applicants without regard to race. In our policy and in our teaching, including our school curriculum, we proclaim that racial segregation is an affront to the informed conscience. While this should be obvious to all with any knowledge of the Catholic Church, we repeat it now in order to make it perfectly clear that the Catholic school system does not offer a refuge from integration.*[331]

Despite the bishop's explicit desire to integrate his schools, many whites began to see the Catholic schools as a desirable alternative to the recently federally desegregated public schools. Bishop Brunini had become disappointed that a number of the Catholic schools were becoming havens for segregationists. He later stated in his memoirs that he had expected a number of his flock to oppose *Brown*. He wrote, "I knew there would be much resistance on the part of most Caucasians and this resistance would also be demonstrated among many of our Catholics."[332]

Thus Brunini was disappointed, but prepared, when a number of Catholics attempted to use his own schools in an effort to ignore *Brown*. Because most Catholics were white, the all-white and nearly all-white schools became an attractive alternative to the racially mixed public schools.

Brunini's 1970 letter explains that the Catholic schools of Mississippi were not in competition with the public schools. In fact, both school systems ought to work for the same end: the betterment of Mississippi's citizens. He urged his fellow Mississippians, Catholic and non-Catholic, to accept integration and work together to improve the faltering public schools. Brunini expressed to his parishioners the importance of supporting the state's public schools. It was the public schools that served the educational needs of the overwhelming majority of young Mississippians: "Make-shift schools, hasty schemes designed to avoid court orders, and emotional appeals to the social patterns of a dead past will do nothing but defraud young Mississippians of their rightful place in tomorrow's world."[333]

The Bishop called on "Catholics of Mississippi to exercise a responsible citizenship in this matter."[334] He concluded his letter by appealing directly to Catholics enrolled in the public schools. He reminded them of their duty not only as Catholics but also as citizens of a state living in historic and pivotal times. If they fled the public schools to avoid desegregation, they would further damage the reputation of their state and church. On the other hand, should they stay in order to take a moral stand, they would be serving their church and state: "Any decisions they make in these days should be made realizing our common responsibility for the public schools of Mississippi."[335]

The fact that a bishop would encourage Catholics to remain enrolled in the public schools is a testament to the seriousness with which Bishop Brunini took school desegregation. The Catholic schools, especially in Mississippi, had a history of financial instability. Its teachers were paid not by the state but through tuition. By encouraging potential enrollees to remain in the public school system, Brunini placed an additional burden on his own schools. Yet Brunini decided it would be better to be poor and justified than wealthy but on the wrong side of history.

A FUNERAL BECOMES A FRACAS: THE AFTERMATH OF THE MEDGAR EVERS FUNERAL

It was a stifling-hot Saturday in June 1963, and Medgar Evers's body lay in a funeral home on Farish Street. Outside, thousands of tired, sweat-soaked mourners stood silent. They had just walked nearly two miles in a funeral procession led by Reverend Martin Luther King Jr.—the rare city-sanctioned march during that tense period. The crowd was supposed to have dispersed

after the procession, but Tougaloo College professor John Salter, among the mourners that day, sensed there was more to come.

Suddenly, a song rose from somewhere in the crowd:

Oh, oh Freedom,
Oh, oh Freedom,
Oh oh Freedom over me, over me.
And before I'll be a slave,
I'll be buried in my grave,
And go home to my Lord and be free.

More people joined in the songs, and people began talking about marching to Capitol Street, ground zero for the weeks-long protest movement that had made Jackson the epicenter of the civil rights movement. Policemen, sensing that the crowd was headed for Capitol, began rushing toward the downtown area.

King had departed the funeral home, bound for the airport, just a few minutes before the songs had begun. Salter knew that King could turn the spontaneous demonstration into a major victory for civil rights in Mississippi—if only he could reach him somehow.

Collins Funeral Home. *Caitlin Starrett.*

Salter, at that point jogging along with the singing crowd, ducked into a Farish Street office building. He was looking for a phone, a way to get a message to King. He looked out a second-story window briefly, at the thousands of streaming protesters. Then the police burst in and arrested him. From a paddy wagon outside, Salter listened as gunfire erupted and watched "vast numbers" of policemen pass by with bayonet-fitted rifles, shotguns, pistols and dogs.

The spontaneous protest of the mourners had been a pivotal moment for Jackson, Salter realized later that day, "the largest black protest in the history of Mississippi."[336]

Tensions had been rising in Jackson for six months leading up to Evers's assassination. In late 1962, NAACP organizers in the city announced a black boycott on Capitol Street businesses, accusing the businesses of discriminating against black workers and consumers. The boycott was organized from the start by Salter. Evers—a World War II veteran, field secretary of the Mississippi NAACP and a friend of Salter's—lent his support to the boycott. The movement picked up steam over the course of months, gaining attention from national NAACP organizers.

The city was not used to being challenged on its race policies, having experienced only one instance of "major racial trouble" before then—in 1961, when 327 Freedom Riders converged on the city and were jailed.[337] Recognizing that Mayor Allen Thompson was the man who could single-handedly change race policy in Jackson, Jackson movement leaders directed much of their correspondence toward him. Thompson took a hard line early, saying forebodingly in an interview that "violence which has plagued other Southern cities will not be tolerated here" and that "the public would be afforded the security of continued law and order."[338]

The movement "took to the streets," as one historian put it, in late May 1963, when three Tougaloo College students, among them a young Anne Moody, sat down at the segregated Woolworth lunch counter on Capitol Street. Before long, the sit-in had drawn a crowd: other demonstrators, including Salter; members of the media; and about two hundred angry whites, who set about verbally and physically abusing the protestors.[339] The demonstration made headlines across the country; one photo package published in the *Salina Journal* in Kansas was titled "Fun and Games in the

South" and showed whites happily lifting battered demonstrator Memphis Norman off the floor and then kicking him down again.[340]

In the days that followed, the movement took to the streets in earnest. Pickets began popping up in different parts of the city (picketers were always arrested). Police scuttled the first mass march of the demonstration, arresting 450 young demonstrators and carting them in garbage trucks to a fairgrounds "stockade." The mass arrests proved to be bad PR for the city, with headlines appearing in papers around the nation providing details of the youths' imprisonment—breakfast in the stockade, for example, was a sad meal of "coffee, syrup and grist."[341]

Governor Ross Barnett, who had responded to the Freedom Rider demonstrations of 1961 by imprisoning the demonstrators at Parchman, offered again to facilitate the transfer of three hundred of the Jackson movement's "agitators and hoodlums" to the prison farm.[342]

Evers found himself "the man in the middle" during the period of protests, torn between the young local activists who had started the movement and the national civil rights leaders who had become interested in the movement.[343] He remained, however, a target; the same day the *Salina Journal* ran its "Fun and Games in the South" spread, the paper also reported that a kerosene bomb had been thrown into Evers's carport.[344]

Mayor Thompson maintained his hardline position even after it had become clear that racial violence had arrived in his city, telling reporters a few days after the Woolworth sit-in that Jackson's police force "can handle 100,000 racial agitators if pressure groups want to send them down here."[345] At the same time, he reassured the public that the crisis was "virtually over" and that "we are going to get along together."[346]

One week later, Medgar Evers was shot in the back by an assassin hiding in a honeysuckle thicket.

A fourteen-year-old Derek Singleton, whose mother had worked with Evers to help desegregate Jackson schools, marched alongside Salter, King and the thousands of others on the day of Evers's funeral. Although most of the accounts from that day focus on the violence that followed the funeral march, Singleton remembers a moment of humanity demonstrated by a helmet-clad police officer who watched as Evers's flag-draped coffin passed by.

"It was so much hatred and animosity being spewed all over, everywhere," Singleton said. "There was a police officer standing on the corner of Capitol and Farish street….I remember that police officer taking his helmet off and placing it over his heart as that flag-draped coffin went by."

Singleton accompanied the other mourners to the Farish Street funeral home. When the spontaneous protest sparked and people began marching toward Capitol, Singleton sensed that things might turn sour and headed for his nearby home.[347]

Anne Moody, who had established herself as a civil rights hero during the Woolworth sit-in and would go on to write an acclaimed account of her experiences, was also there at Evers's funeral and witnessed and recorded what Salter missed as he waited in the back of a paddy wagon.

The procession, led by "one hard core of angry Negroes," marched toward Capitol Street for seven blocks, police watching the march from the sidelines all along. Then, just as the group was about to reach Capitol Street, it encountered a "solid blockade" of police.

"This was where they made everyone stop," she wrote in her account of the day. "They had everything—shotguns, fire trucks, gas masks, dogs, fire hoses, and billy clubs."

Capitol Street, the focus of the Jackson Movement boycott. *Josh Foreman.*

As police "knocked heads, set dogs on some marchers, and made about thirty arrests," the protesters grew angrier and began throwing rocks and bottles. Spectators began throwing objects from second- and third-story windows, and police readied their firehoses. Despite the shower of thrown objects, the police barricade was holding, and the marchers were unable to break onto Capitol Street.

As the confrontation grew increasingly violent, a Justice Department lawyer named John Doar, who had helped James Meredith gain admittance to the University of Mississippi a year earlier, stepped between the two crowds and was somehow able to defuse the situation. Wearing a shirt and tie, slacks and dress shoes, he approached the demonstrators with arms raised. "You can't win with bricks and bottles," Doar said to the crowd. They listened, dispersing soon after.[348]

"After he talked for a few minutes," Moody wrote, "things calmed down considerably....After that it was just a clean-up operation."

Bill Minor was on hand to witness the confrontation and remembered shortly thereafter walking over to St. Peter's, the downtown cathedral, to pray for the sins of his fellow Mississippians.[349]

Although Salter's and Moody's accounts have black Mississippians at the center of the post-funeral uprising, the *Clarion-Ledger*, known in those days as a platform for pro-segregationists, painted a different picture. The march toward Capitol Street was not a homegrown expression of black anger, it claimed, but rather a ploy of "agitators"—using the Citizens' Council lingo of the day. A striking front-page photo in the following day's *Clarion-Ledger* showed two young black men hurling objects at a line of helmet-clad police; the banner headline accompanying the photo, however, blamed "white-led agitation" for the violence.

The accompanying story blamed white Tougaloo College staff members for inciting the spontaneous protest (Salter is named later in the story). The police are presented as well-intentioned victims who had only organized in such numbers that day to "insure no traffic would interrupt the marchers." There is no mention of Moody's "knocked heads" or the siccing of dogs—in fact, the story makes a point of mentioning that the police showed total restraint: "Dogs, fire trucks and armed men were called but were on display only, and were not used."[350]

Leading up to the Evers assassination, the *Clarion-Ledger* had covered the Jackson movement with thinly veiled derision, referring to demonstrators who had been arrested and imprisoned in the fairgrounds stockade as "fish" ("Police catch a big fish and 90 smaller ones") and adding quotation marks around the phrase "non-violent" when referring to demonstrators.[351]

In a later interview, Bill Minor called the paper, owned by the Hederman family at the time, "an instrument of perpetuating the system of segregation on a daily basis." "Bigotry would be at the soul of it in my estimation," he added. "Although I would say 90 percent of them would go to church on Sunday and be in the amen pew, so to speak."[352]

Salter was taken by the paddy wagon to the fairgrounds stockade, where he weathered the rest of the hot afternoon in silence. He was eventually moved to the city jail, charged with disturbing the peace and interfering with officers, and finally bonded out by friends.

"I knew that the developments of the day were going to have an effect upon the Jackson movement itself," he wrote later in an account of his experience. "I could not see how, after everything that had occurred, the effect could be anything but constructive."[353]

Two days after the funeral, Mayor Thompson received a phone call from President John F. Kennedy (who had met personally with Bishop Gerow earlier that day).[354] The following day, leaders of the Jackson movement and Thompson worked out a deal—the city would hire six black policemen and black crossing guards for some black schools. It was a small concession from the mayor and Jim Crow policies remained in the city, but the "small victories" were beginning to take a toll on Jim Crow.

DEREK SINGLETON, WHO QUIETLY INTEGRATED JACKSON'S SCHOOLS

Derek Singleton was born in 1949 and grew up with the civil rights movement, in a little house in the center of Jackson. As a young teen in the early '60s, that house received a frequent visitor: Medgar Evers, the face of the civil rights movement in Mississippi. Evers would visit the Singleton residence

Derek Singleton. *Josh Foreman.*

to confer with another civil rights leader, one who never achieved fame: Singleton's mother, Edna.

Edna Singleton was a beautician who ran a salon inside her Maple Street home. She had no boss, no superior who could threaten or intimidate her, no one to pressure her if she spoke out against segregation. And she did just that, after conversations with Evers. She did so on her son Derek's behalf. He doesn't remember the adults filling him in on their plans. Nevertheless, Edna Singleton ensured that her son's name would be synonymous with desegregation in Jackson when she filed a federal suit on his behalf in 1963. The suit asked that Jackson's schools be desegregated. Several other children were named as plaintiffs in the suit, including two of Medgar and Myrlie Evers's children.[355]

Although the Singleton suit was directed at the Jackson Municipal Separate School District, Derek Singleton would never attend Jackson public schools. Instead, he would desegregate another Jackson school in the mid-'60s: St. Joseph Catholic School, becoming one of the first black students to study alongside whites in the city of Jackson. He was thus indirectly responsible for desegregating two separate school systems in the 1960s—personally in the Catholic schools and legally in the public schools.

As the Singleton suit made its way through the court system, Jackson's public schools remained segregated. Derek Singleton had been attending all-black Catholic schools, which his mother considered more academically rigorous than their public counterparts, up until the tenth grade. Two years from graduating, an opportunity arose for Singleton to move into the previously all-white St. Joseph thanks to church leaders who decided to forcefully act on desegregation, which had been decreed a decade earlier by the U.S. Supreme Court in *Brown v. Board of Education.*

Derek Singleton arrived at St. Joseph a high school junior in 1965, five years before desegregation began in earnest in public schools in Jackson. He remembered a mostly welcoming school with a few exceptions. He joined the football team and tried to ignore any negativity that came his way.

Bishops Richard Gerow and Joseph Brunini, the men who were ultimately responsible for the diocese's push to integrate its schools, came to that decision after a painstaking process of "discernment," the Catholic tradition of decision-making. With little grass-roots support, integration was a difficult sell to many of Mississippi's white Catholics. The bishops could not force integration on purely moral grounds without risking the well-being of the Catholic schools themselves. They were in the unenviable position of promoting integration to tuition-paying segregationists. Gerow and Brunini made several attempts to introduce piecemeal integration before a definitive 1969 decision that made segregation and Catholic education mutually exclusive. A gradualist approach and a strong economic pitch made integration more palatable to many of Mississippi's white Catholics.

The decision to desegregate the Catholic schools of Mississippi at the first grade level came in 1964. The following year, all grade levels in the Catholic schools were officially desegregated. Just as the Supreme Court had tried to soften the inevitable backlash of its *Brown* decision by setting a lax timetable, so, too, did the Catholic Church in Mississippi attempt to gradually acclimate its angry white parishioners to the winds of change. Integration would not happen all at once. Instead, the youngest grades would be desegregated year by year. The plan was to have fully integrated schools in just over a decade. By admitting a few black students in the younger grades each year, the church hoped to retain its white supremacist congregants and, at the same time, nurture a modicum of racial tolerance in the students.

Despite the gradual easing in of integration, some of the whites Derek Singleton came into contact with at St. Joseph found it intolerable. An assistant football coach made it known that he didn't like Singleton.[356] "He sent off a vibe that let you know, 'I could give a rat's ass about you being here,'" Singleton said.

One student waved a Confederate battle flag at a home football game. Another antagonized Singleton over and over. Finally, the bullying came to a head one Friday afternoon during a pep rally. "This guy kept hitting me with spitballs, you know, hitting me with a little rubber band shooting spitballs," Derek Singleton said. "I ignored it and ignored it and finally I got fed up and I jumped up in the guy's face and I said, 'hey man.' Anyway, we got into it and the next thing you know, 'boom.'"[357]

School let out for the day, and nothing came of the confrontation—or so Singleton thought. When he arrived at school on Monday, he saw a crying classmate and asked what was wrong. It turns out Singleton's spitball-shooting classmate had been expelled over the weekend. The expulsion of a white student over the bullying of a black one was a forceful show by school leadership that integration would be happening and resistance would not be tolerated.[358]

Singleton's presence in a formerly white school provoked more severe reactions from other schools during away football games. On one trip to Centreville in southwest Mississippi, Singleton and his teammates received a particularly ugly welcome: a burning cross at midfield during halftime.

Hoping to avoid an exodus from its schools, Catholic schools in Jackson had eased into integration in other ways. One policy required black students to be Catholic in order to enroll in a post-*Brown* Catholic school. Marge Baroni explained, "When the decision was made to integrate the Catholic school, they, in order not to integrate it too fully, and not to make it too open, and not to do the job thoroughly, the rule was that only Blacks who were Catholic could go there."[359] The intent was clearly to keep the tuition-paying white Catholics enrolled. The church did not want a white-flight from its schools.

Nevertheless, a number of Catholic parents did indeed flee the recently integrated Catholic schools. From 1966 to 1967, those Catholic parents who did not want their children mingling with black classmates took their children to the still segregated public schools. When the public schools were integrated the following year, they enrolled in their last resort: the private academies that sprang up all over the state.

St. Andrew's School, a private Episcopal school founded in Jackson in 1949, had faced a similar dilemma when an idealistic clergyman named Edward Harrison pushed to open dialogue between blacks and whites in 1961. Fearing that the clergyman's sympathy for civil rights would lead to integration of St. Andrew's, a group of the school's trustees asked that Harrison resign from his position of leadership within the Episcopal Church in Jackson. Harrison's idealism eventually won out, and St. Andrew's was integrated in 1966.[360]

Whereas St. Joseph and St. Andrew's took steps to voluntarily integrate, Jackson public schools waited until they were forced by the federal

Jean L. Puderer

Jo Ann Raulins

Paul R. Reihle

Ginny L. Remm

Mary Ann Rice

Stephen Riley

Beth Robertson

Robert A. Saway

Thomas P. Scanlon

P. Jeffrey Schoeneck

Susan Siekmann

Raul Sierra

Renee A. Silbernagel

Lawerence Sims

Derek Singleton

Derek Singleton's yearbook photo from his time at St. Joseph Catholic School. *St. Joseph Catholic School.*

government.[361] Jackson's all-white school board eventually drafted the actual plan for integration, but not until it was forced to by a Federal District Court decision, on the Singleton suit.[362] Edna Singleton's efforts on behalf of her son finally forced the integration of Jackson's schools. "Singleton" became the name associated most with the integration of Jackson's public schools.

Integration of Jackson's public schools happened largely overnight, with about 24,000 public school students returning from a nine-day "holiday" to integrated schools.[363] About 4,500 students simply failed to show back up for school after the integration break. Many of those students ended up at private schools sponsored by the Citizens' Council.[364] The number of private schools in Mississippi increased from 17 in 1963 to 155 in 1970. Jackson's public schools lost a quarter of their students from 1969 to 1970.[365]

Although Singleton's admittance to St. Joseph was a step toward integration, four years later, Mississippi's Catholic schools had seen very little change in the way of integration. Superintendent James Gilbert felt the need to remind one of his wavering principals that "the policy of the Mississippi Catholic School Office is full integration of student bodies and full integration of faculties."[366] His letter, dated November 21, 1969, goes on to explain that Catholic school integration must occur quickly, and he made it clear that the principal must begin looking for black teachers who would join the faculty the following school year. Gilbert also warned against accepting students who were fleeing the public schools because of desegregation: "I hope that no Principal will accept students during the year who are running from integration....We should use the policy of not accepting any students into the parochial schools this school year unless they have moved in from out-of-town or state."[367] Gilbert's refusal to accept transfer students was based on principle. Catholic schools generally sought ways to attract students. The bills and salaries were paid via tuition; the more enrolled students, the greater the operating budget. And yet the superintendent was authorizing his principals to turn away potential students. Gilbert explained his position: "I am well aware that parochial schools are suffering financially but I would rather suffer that way than from operating on un-Christian principles. So, don't accept students who are running from integration."[368]

On December 6, 1969, the principals and school board of the Catholic Diocese of Jackson agreed unilaterally to actively integrate all Catholic

schools. Henceforth, Mississippi's Catholic schools would accept students regardless of race. The second resolution of this momentous meeting stated, "Be it resolved that the Diocesan School Board and the Principals of the parochial schools in Mississippi go on record as reaffirming completely and totally the diocesan policy of full integration of student bodies and of faculties in the Mississippi Catholic schools."[369] The Diocese of Jackson had previously encouraged integration—now it would require it.

Bishop Brunini continued to push for forceful integration of Mississippi's Catholic schools. He mandated in 1970 that Catholic schools' faculties should be integrated along with its student bodies. He also banned the opening of new Catholic schools that might accommodate students fleeing integrated public schools. His plan is a testament to both his moral convictions and his practical nature. His campaign to desegregate had finally gained enough momentum to be effective and ensure that the state's Catholic schools would retain a significant number of their tuition-paying whites. His actions made it clear that the Catholic Church would no longer lag in the rear of school integration.

Derek Singleton left Jackson after graduating from St. Joseph, continued his education at Florida A&M University and joined the U.S. Army. He eventually returned to his home city, though, and lives there now. When asked whether he ever thought of himself as a figure in Jackson's history, Singleton replied modestly. "I was a teenager," he said. "You do what you're told to do and be done with it. I knew integration was important only from the fact of the matter of fairness and equity. That was my whole thing about it—achieving societal equity and fairness. That's all I cared about."

THE TRIUMPH AND TAINTING OF THE PEARL RIVER RESERVOIR

On October 6, 1962, Ross Barnett, the governor of Mississippi, stood celebrating in the home section at the University of Mississippi's Hemingway football stadium. It was homecoming, and a photo from that Saturday shows the man ebullient, his body twisted with excitement, one arm flung into the

air in a spasmodic salute.[370] His mouth opens wide in a smile, and an all-white crowd—many waving Confederate flags—cheers behind him.

Six days earlier, the university had been consumed in a legitimate riot, a battle between segregationists and federal marshals complete with gunfire, bombs, hundreds injured and two dead.[371] The riot began with the arrival on campus of James Meredith, a black man who wanted to enroll in the whites-only university.

But the seeds of the riot had been sown earlier by the governor himself. It was Barnett who took a personal interest in keeping the state's schools segregated, going so far as to have himself appointed a special registrar by the state's college board. It was Barnett who organized police into a kind of anti-federal battalion. It was Barnett who enlivened his supporters with fiery anti-government rhetoric. And it was Barnett whose opposition to integration earned him infamy on a national scale.

During those years of strife that defined Barnett's governorship, something different was happening in Jackson. Bulldozers were carving out a basin for what would become a Pearl River reservoir, what one scholar described as "an illustrious example of urban and regional planning." It was one of the biggest public works projects in the city's history, and Barnett was at the center of it too—not because he had planned it, funded it or worked toward making it a reality. Barnett would become the face of the project because he had defied integration so vehemently—infamy abroad was adoration at home.

The Pearl River has been important to the city of Jackson since the area was a French trading post called LeFleur's Bluff.[372] When state officials were looking for a good place to put a capital city in 1821, they chose the Bluff, which overlooked the Pearl.[373] Jackson remained a literal and figurative backwater for decades—by 1900, the population was only 8,000. But the city's population began to swell, and by 1960, there were nearly 150,000 people living there.[374]

Leaders from the Jackson area began to wonder whether the Pearl could supply water and sewage removal to the rapidly growing city. There was also the problem of flooding—the Pearl overflowed its banks every year, causing nearly $1 million in damages annually. A young World War I veteran named Mitchell Robinson first had the idea for a dam on the Pearl in 1926. It took a

quarter century of lobbying on Robinson's part before leaders finally began to take the idea seriously (and many still derided Mitch's idea, giving the project the nickname "Mitch's Ditch"). By the late 1950s, the leaders of five Mississippi counties were cooperating on the idea, clearing all the zoning hurdles, successfully lobbying the public for funding and forming a special administrative body: the Pearl River Valley Water Supply District. In July 1960, seven months after Ross Barnett had been elected governor, ground was officially broken on the project. Five years later, the city of Jackson was just a few miles' drive from a thirty-thousand-acre lake with 150 miles of shoreline.[375]

Mitchell Robinson. *Mississippi State University.*

The start of construction on the Rez was a major accomplishment for the state of Mississippi. James Sorrels, who chronicled in his master's thesis the wrangling it took to get the Rez project started, put it in glowing terms: the visionaries who had thought up the reservoir project had seen it to fruition through "aggressive selling, legislative enactments, county referendums, court hearings, and a substantial sum of money." The reservoir project was the result of "collective thinking" that would "grace human life in the area for generations to come."[376] In his eyes, the citizens who planned, executed and funded the project were heroes, and the project itself was an inspirational example of community-focused, long-term thinking.

As Sorrels predicted, the benefits of a Pearl River reservoir manifested themselves in the decades after its construction. The lake provides a reliable water supply for up to 500,000 people.[377] Flooding problems came under control (with one notable exception in 1979), thousands moved to live on the shores of the lake, businesses popped up and millions began to visit the Rez and its parks, trails, marinas, restaurants, sporting venues and campgrounds each year.[378]

Barnett's cheery appearance at the 1962 homecoming game was in keeping with his behavior throughout Mississippi's integration test. The city of Jackson had provided the stage for what had, up to the Ole Miss riot, been the state's most notorious stand against integration. In 1961, groups of black and white Freedom Riders entered Mississippi by bus and train in an attempt to integrate transportation. They were arrested upon arrival by Jackson police, and Barnett took an interest in their punishment and humiliation, personally overseeing their transfer to the maximum-security ward of the state penitentiary.[379]

Barnett had fought to keep Meredith out of the university, asking the state college board to appoint him a special registrar so that he could personally block Meredith's admittance.[380] When that effort failed, he organized a picket of two hundred helmet-wearing, baton-wielding state police to physically block Meredith's arrival on campus.[381] All the while, Barnett was framing the conflict as a David and Goliath–style battle, with Mississippi standing for its principles against a tyrannical federal government. In a televised speech three weeks before the riot, Barnett said the forced integration of the University of Mississippi represented "the moment of our greatest crisis since the War Between the States." He went on: "We must either submit to the unlawful dictates of the federal government or stand up like men and tell them no….There is no doubt in my mind what the majority of loyal Mississippians will do."[382]

Barnett's supporters—including state officials in positions of power—heeded his call, resorting to vile tactics to punish Barnett's opponents. William L. Higgs was a white integrationist lawyer who had helped Meredith enroll at Ole Miss and worked on several other civil rights cases. He was arrested at the end of 1962 and charged with contributing to the delinquency of a minor. While awaiting his trial, Higgs left the state and refused to return. He was convicted *in absentia*, nevertheless, and given the maximum sentence. Later, the boy involved in the case swore before two Pennsylvania detention center officers that Higgs had been set up. The boy was asked what the Mississippi detective asked him. The boy replied:

> *Did you ever have unnatural relations with him. He asked me if Mr. Higgs ever messed around me or used me as a girl. The first two times I said No.*

Ross Barnett. *Flickr.com/Wystan.*

Then they said they could put me up in reform school for four or five years on different charges. Then the detective asked me again what went on at night and about unnatural relations. THAT IS WHEN I TOLD THEM THAT HE HAD UNNATURAL RELATIONS.[383]

Mississippi's Citizens' Councils and State Sovereignty Commission would go to any extent to demonstrate that integrationists, both white and black, lacked "good moral character" and therefore deserved whatever retaliation that came their way.[384]

Derek Singleton and other black Mississippi youth had waited eight years—since the *Brown v. Board of Education* decision mandated that Mississippi's schools desegregate "with all deliberate speed"—for Mississippi's schools to actually become integrated. They followed the Meredith saga closely; Singleton said that it inspired him to work within the Jackson movement.

Finally, facing imprisonment and massive fines for defying federal court orders, Barnett relented, withdrawing the police picket from campus and allowing Meredith to enter the university. By that time, though, segregationists (many Ole Miss students) from inside and outside the state were primed for battle, and violence erupted.[385]

As the homecoming photo showed, Barnett was not appalled by witnessing the near-destruction of the University of Mississippi. Instead, he was elated. He clarified his feelings a few months later in another televised address: "Students at Ole Miss have shown great courage and restraint....I want to now commend those students and their parents for their wonderful attitude and conduct."[386]

James Meredith. *Charlie Brenner.*

Barnett continued his fight against Meredith even after the man was taking classes at the university, lobbying to have him expelled for making "inflammatory" comments after Meredith spoke out against southern governors' reluctance to integrate.[387] Years later and no longer governor, Barnett defended his actions: "Generally speaking, I'd do the same things again."[388]

Up to 1963, Jackson's reservoir project had been accurately but innocuously called the "Pearl River Reservoir." Then, eight months after the Ole Miss riot, it was officially anointed the Ross R. Barnett Reservoir. The decision to name the lake after Barnett was a reactionary middle finger to his critics (which included much of the rest of the country), an expression of what historian C. Vann Woodward has called the "solidarity of Southern resistance to change." The official minutes from the meeting show that the board's reasoning was disingenuous from the start.[389]

Perhaps anticipating that the decision to name the Rez after Barnett might come under scrutiny, the PRVWSD provided a lengthy rationale for the naming at its May 10, 1963 meeting. The rationale makes only a halfhearted effort to connect Barnett to the reservoir project, noting that he had connections to the five counties touching the reservoir (he went to college in Jackson, worked as a college student in Scott County and so on) and that he had "given freely of his time, talent and energy to forward the work of the Pearl River Valley Water Supply District"—note that he was the governor at the time of its construction; giving freely of his time and energy to aid one of the biggest public works projects in Jackson's history could presumably be considered part of a governor's duties.

Other parts of the rationale use creative language to present Barnett as a sort of moral exemplar. Barnett had the "courage of conviction" and was dedicated to the "rights of the sovereign states" and the "due and orderly process of law, by heritage, training and belief." With some decoding, it's clear the board was praising Barnett's refusal to integrate Mississippi, even with the federal government demanding it.

Some parts of the rationale stray into fantasy: "Gov. Barnett has demonstrated leadership in all fields of government...all Mississippians bear a deep affection and a great respect for Gov. Barnett." Never mind that 42 percent of the state's population in 1960 was nonwhite (nearly 1 million Mississippians), whom Barnett fought bitterly to bar from attending the state's universities, sharing trains and buses with whites, swimming in public pools, eating in restaurants and so on.[390] And never mind that there were many vocal white Mississippians who did not appreciate Governor Barnett turning the state into a battleground over integration. A group of seventy-two Oxford residents, for example, wrote to the governor four days before the riot urging him to "keep the university open, protect its accreditation, and preserve its good name."[391] The group included the multi-term mayor of Oxford, Richard W. Elliott.[392]

The Ross Barnett Reservoir. *Josh Foreman.*

Conspicuously missing from the list of those present at the 1963 naming meeting is Mitchell Robinson, for whom the reservoir had originally been named (if unofficially) and who had seen the project through from conception to construction.[393] The project had been so central to Robinson's work as a public servant that he took out a large campaign ad in a 1959 issue of the *Clarion-Ledger* detailing all the work he'd done on the project. He proudly referred to the project as "Mitch's Ditch" in the ad. Little did he know that his life's work would soon bear the name of a different man.

REVENGE OF THE PEARL

The floodgates had opened, the river had jumped its banks and parts of Jackson lay eight feet underwater.[394] Still, the Pearl continued to rise.

George Woodliff, a young Jackson lawyer, made his way to work that Monday, April 16, 1979, as the Pearl River poured into the east part of the city. It was the day after Easter, and he was one of the few people to venture downtown, taking a circuitous route to his office and avoiding flooded roads.

Woodliff remembered arriving at his building, Capitol Towers, taking the elevator to the nineteenth floor and being astonished by the view.

"If you looked out the windows facing east, you could see the flood," Woodliff said. "That would be the area known as the fairgrounds. All of that was underwater. It was an amazing sight to see how extensive the flood was. Pretty much all that area close to the Pearl River, on both sides, was underwater."[395]

Aerial photos of the fairgrounds taken at the peak of the flood show just how severe the damage was. A few rooftops stood above the water, but the fairgrounds were, for the most part, a placid sea of chocolate milk. Light poles bristled up here and there, along with the roof of the Mississippi Coliseum and the flat roofs of surrounding buildings. Raised roads on the sides of the grounds outlined the newly formed lake.[396]

Woodliff's home, ironically, was not affected by the flood, even though he lived near the banks of the Ross Barnett Reservoir, that dammed section of the Pearl River that had been created two decades before to prevent such flooding. But thousands of Jacksonians living just south of Woodliff's house *were* affected. More than fifteen thousand people in Jackson and Rankin County had fled their homes ahead of the flood.[397] One thousand homes lay partially underwater that Monday.[398]

More could have been done by the National Weather Service to prepare and alert Jacksonians for the flood.[399] The water level of the Ross Barnett Reservoir, which was controlled by floodgates, could have been managed better. But nothing, ultimately, could have saved Jackson from the monumental volume of rain that dumped down on it, turning the Pearl River into an angry "Jezebel," as one editorial put it, who cut a wide and wrathful path through the city.[400]

Although few Jacksonians could have conceived of the scope of the flood before it arrived, warning signs that something terrible might be coming began to show several days before the flood. Thunderstorms had dumped rain on the city that Wednesday, four days before the Pearl jumped its banks. Acting as a harbinger, Bogue Chitto Creek swelled, flooding the Presidential Hills neighborhood in northwest Jackson and prompting evacuations and rescues. A story in that Friday's *Clarion-Ledger* announced Jackson had begun a "mop-up" after the week's heavy rains. In the story, reporters

ominously noted that officials had opened the reservoir dam's floodgates wider, "threatening to swell the already deluged Pearl River." The paper also carried a story of heavy rains and flooding in Winston County, near several streams that converge to form the Pearl River.[401]

The night of that Friday—Good Friday—seems to have been the point when alarms bells began to sound in earnest. Evacuations began that night, with about five hundred families leaving by Saturday. Women's Hospital in Flowood evacuated its patients and staff, including fifteen infants. City workers and National Guardsmen shored up two miles of levees with timber. Power stations began to fail, leaving thousands of Jacksonians briefly without power. Floodwaters had already begun eroding Interstate 55, and the thoroughfare was closed.[402] Aerial photos showed Jackson residents piling their belongings onto rooftops.[403]

A young Tommy Couch received a call from his wife that night. "A lot of people are moving out," she told him. "You know this flood is supposed to be coming tomorrow."

A friend accompanied Couch to his house that night, and with the help of neighbors, they stacked furniture up on concrete blocks. He secured all the possessions he could but left a beat-up Mercury car in his driveway, hoping that the flood might dispose of it for him. "I mean, I had insurance," Couch said. "If it floods, then so be it." Couch then sought refuge with his family in a relative's house.

A banner headline from the next day's *Clarion-Ledger* announced that Jackson was facing a "state of emergency," with extensive flooding expected in the eastern part of the city. Mayor Dale Danks Jr. had mobilized city resources by that point, asking for evacuation and relief help from the Red Cross, putting all city employees on call and requesting the state send more National Guardsmen. City firemen were tasked with organizing a boat rescue squad, and three hundred city policemen were ordered to work twelve-hour shifts patrolling the city in boats to help prevent looting.[404] Prisoners from the state farm at Parchman were brought to Jackson to help shore up levees.[405] Many areas of the city had already been inundated.

Ross Barnett Reservoir manager Charles Moak found himself in the difficult position of trying to regulate the outflow of the reservoir's dam. Release too much water too fast, and the areas south of the dam (Flowood and East Jackson) would be inundated with water; release too little water, and the Pearl River could overflow the reservoir itself, making its way south anyway—or, worse, bursting the dam altogether, causing an unmitigated catastrophe. Moak decided to increase the amount of water passing through

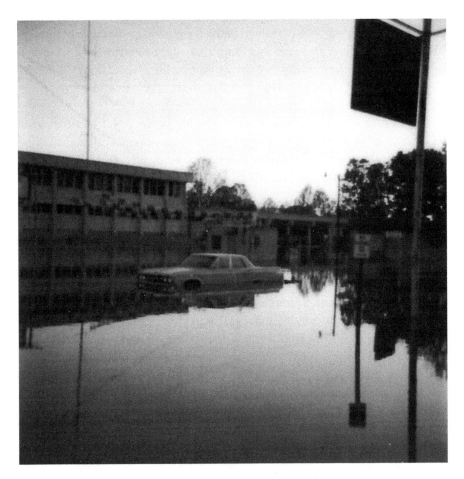

Jackson during the flood of 1979. *Herb Foreman.*

the dam's floodgates. By Monday, the reservoir's discharge had doubled, to 56 million gallons of water per minute. It would eventually hit 60 million gallons per minute. Even still, more water was pouring into the reservoir, from upriver, than out.[406]

Alarm bells had sounded for city officials and thousands of residents, but some Jacksonians still ignored the severity of the imminent disaster. George Woodliff's wife, Jill Woodliff, remembered seeing the newspaper

warnings. A co-worker of hers lived in the floodplain, and she remembered him leaving work Friday and spending that night moving all his family's possessions from the first floor of their house to the second floor. While the co-worker and his family moved their furniture, their next-door neighbor hosted a barbecue.

"It just didn't sink in that this was really happening," Jill Woodliff said. "The next-door neighbor was just kind of dumbfounded that they were going to all this trouble. It turns out they were vindicated."[407]

Although the reservoir had risen so high that emergency precautions were being taken to prevent it overflowing its banks or worse, at least two men decided on Saturday to go sailing on it. The current created by the reservoir's tens-of-millions-of-gallons-per-minute discharge pulled the men's boat toward the dam's gaping floodgates. The boat foundered on a concrete barrier near the gates, and the two men were rescued by a group in a larger, motorized boat.[408]

A mobile home park a stone's throw from the floodgates was inundated. One woman sat on the road that ran across the top of the dam that Saturday, looking down on her neighbors as they tried to salvage their waterlogged belongings. "We weren't even warned," she told a reporter.[409]

Even many of those who had taken drastic precautions against the flood were left helpless when the waters came. A homebuilder named Lucian Harvey Jr. spent Saturday morning constructing a levee with a backhoe and dump trucks around his entire palatial home. The red clay levee held for a few hours, and then several feet of water poured in.[410]

The Pearl River finally crested on Tuesday, April 17, and floodwaters began to slowly recede.[411] Jackson began thinking about cleaning up sewage and aiding victims more than the feverish scramble of survival of the past few days.

Aerial photos such as those taken by Erwin Ward of the *Northside Sun* showed areas all over Jackson covered with still water. One photo shows Hanging Moss Creek swollen to gargantuan size, covering large parts of Canton Mart Road. Another shows Interstate 55, with only the faint outline of the actual pavement visible—and in some places none at all. In another, the Twin Lakes subdivision is all treetops and rooftops. Other photos show water covering homes above their windows. In another, the Quarter shopping

Jackson was covered by eight feet of water in places. *Herb Foreman.*

center on Lakeland Drive sits in a lake, a sign posted where its parking lot once was: "Slow, leave no wake."[412]

Westbrook Road had been transformed into a canal, and people traveled up and down it in canoes, motorboats, rowboats and even ski boats at the height of the flood. Homeowners looking to inspect the damage did so by boat—paddling, in some cases, right through their front doors.[413]

The Pearl had risen above railroad trestles, washing out the beds of slag that supported crossties and rails. In places, tracks seemed to be suspended in air with nothing under them at all. Much of Jackson had been cut off from rail service. For months, railroad crews worked to carefully restore the track beds.[414]

When Tommy Couch returned to his house to take stock of the damage, he found it half submerged. Floodwaters eventually reached eight feet up the house. Everything was ruined, except for the old Mercury—a neighbor had rolled it up a hill, and it was not damaged.[415]

Derek Singleton, by this point living in Panama and working as a jungle warfare instructor for the U.S. Army, remembered reading the newspaper and seeing pictures of the nearly submerged Coliseum. "I'm going like 'whoa'," he said, "did the dam break?"[416]

A writer visiting Jackson two weeks later described the visual scars left by the flood:

> *A visitor driving into Jackson on Interstate 20 sees only a sleepy brown stream where a murderous torrent flowed two weeks before. But the tall trees alongside the highway offer stark evidence that the flood did pass this way: the bottom 10 or 12 feet of each tree are stripped of most branches, and the few left are brown and encrusted with mud. Halfway up, the trees burst into bright green color, leaves that escaped the ravages...*
>
> *Here the houses are stained with mud as high as three and four feet off the ground. Ruined furniture, rugs and assorted debris litter the yards.*[417]

Jacksonians began asking how such a catastrophe could have happened. Mayor Danks pointed fingers at the U.S. Army Corps of Engineers and the National Weather Service, saying that the agencies had provided "woefully inadequate" forecasts. It turned out that a "river desk" at the National Weather Service's Jackson office had been left unmanned after its hydrologist had been reassigned to another state. A young Mississippi senator named Thad Cochran promised a full investigation.[418]

Fingers also pointed toward Moak, the reservoir manager who had made the decision to open the reservoir's floodgates amid the mounting crisis. A circuit court judge named Dan Lee, whose house was flooded, threatened a grand jury investigation into the management of the reservoir, charging its board of directors with keeping its water level too high in order "to promote recreational use."[419] Moak deflected criticism by saying that the reservoir's purpose was water supply and recreation—*not*, he implied, flood control. The statement contradicted the fact that the reservoir had been inspired, designed and built for the express purpose of flood control.[420]

A front-page editorial in the *Northside Sun* addressed the search for blame poignantly and acknowledged the reality that the flood was so massive in scope that perfect planning or response would have been impossible:

These feelings are understandable when one considers that the circumstances resulted in tremendous property loss or in tremendous inconvenience. The Sun feels, however, that all city and other governmental agencies, emergency workers and the utility companies, along with thousands of volunteers, did an outstanding job though sometimes results were not as one might desire.

No one involved in this disaster had set himself up as an expert, an authority, on the proper handling of a disaster of this record proportion. No one had asked for this job. But these people responded with the best they had, drawing upon deep reserves of strength.

The statistics compiled after floodwaters receded were staggering. Twenty inches of rain had fallen on Winston County in thirty-six hours—about what the city of San Francisco receives in a year.[421] The flow of the Pearl River had swollen to thirty times its normal volume.[422] The water level had reached forty-three feet, twenty-five feet above flood stage and a record for the river by five feet.[423] The flood caused $500 million in property damage.[424] It was the worst flood in the city's history.

Despite that, thousands of Jackson residents had worked tirelessly to mitigate the damage. When the ordeal was over, only one Jacksonian had lost her life: a four-year-old girl who had fallen off her porch into the floodwaters.[425]

TOMMY COUCH, LOCAL MOGUL

In a back corner of the Malaco Records complex in North Jackson sits a modest concrete building. Inside are shelves reaching up to the ceiling, packed with master recordings from Malaco's fifty-year history—row after row of shelves.

In 2011, a tornado swept through the area. Malaco's complex was hit hard. Its studios and offices were all but destroyed, but its treasures—master recordings from Dorothy Moore, King Floyd, Jean Knight, Z.Z. Hill and many others—survived with little damage.

The little concrete building seems innocuous, but when Tommy Couch Sr.—the founder of Malaco Records—designed it years ago, he was thinking of exactly the kind of disaster that struck in 2011. He had steel reinforcement built into the walls and floor of the building and a heavy door placed on its front.

Inside the Malaco Records vault. *Josh Foreman.*

Couch and the Malaco crew rebuilt on the same premises where they've been recording for more than fifty years, and the master recordings are still tucked away in the concrete vault. They are a compressed version of Jackson's musical history and a testament to the influence of Malaco Records, a genuine Jackson institution.[426]

Tommy Couch Sr. grew up in the little town of Tuscumbia, Alabama, right next door to Muscle Shoals. Nashville's WLAC radio station sent out a fifty-thousand-watt signal that reached Couch's ears. Through WLAC and the music scene in Muscle Shoals, he was exposed to soul music. Even though his town was totally segregated, he grew to love music made by black artists. "A black hit then was a Top 40 hit," Couch said. "The charts were intermingled."

Couch enrolled at Ole Miss in 1961 with the intention of earning a degree in pharmacy. He was a good student and a popular one, as evidenced by his leadership of the Pi Kappa Alpha fraternity.[427] At Ole Miss, he continued

listening to black music, exploring artists such as James Brown, the Isley Brothers and Benny Spellman. And he wasn't the only Ole Miss student who liked that kind of music.

"Ray Charles was my favorite singer," Couch said. "You'd go in the Grill at Ole Miss and most of the music you heard was Ray Charles on the jukebox. Nobody thought, 'Oh he's a black singer.' It was just great music."

One Saturday on a visit back home to Alabama, Couch was approached by an acquaintance at the town soda fountain. The man played saxophone in a band and asked Couch if he would book them for a show in Oxford. "I said, 'Well how does that work?'" Couch said. "He said, 'Well, if you get us to come down, you make a commission.' I said, 'Well what kind of commission?' He said 10 percent. I said, 'Well dang. How much do y'all charge?' He said $250. I said, 'So all I have to do is get y'all to come down there and I'll make $25?' He said yeah. So that's how I started. I thought that sounded OK."[428]

Thus began Couch's career booking bands in Oxford. Couch would often book bands for his own fraternity's parties. Within the first year, he was booking bands from the Stax label in Memphis, the likes of Booker T. & the M.G.'s and Rufus Thomas. His contacts extended to New Orleans, and Ernie K. Doe, Benny Spellman and Slim Harpo began turning up at the Pi Kappa Alpha house in Oxford. Couch's mind for money and music extended beyond the parochial confines of a single University of Mississippi frat house. Soon he was booking parties for rival fraternities. The acts would play for $1,000 at the agreed-on frat house. Then Couch would book the band at his own frat house at a fraction of the cost—the band was already in town anyway, expenses paid.[429]

When Couch began his studies at Ole Miss, the university was still segregated. The year after he enrolled, James Meredith arrived on campus with the backing of the federal government. Couch remembered the night of the riot. He had been driving on a country road, unaware of what would transpire, when he saw flashing lights in his rearview mirror. "It was a highway patrolman," Couch said. "I thought, 'Oh shit.' I started to pull over, and they shot by me. All of them, and there were about five of them. They were going to Oxford."

Couch turned toward Oxford and found a city beset with media, federal marshals and protesting students. He drove out to Sardis Lake with his girlfriend and then returned to Oxford that night. When they returned, they found a campus blocked off, with cars parked on the side of the road leading out of town. There were a lot of pickup trucks, with a lot of gun

racks. "Apparently there was a call out on the radio for every redneck that had a gun to show up and, you know, do whatever they're supposed to do," Couch said.

Couch spent hours that night walking around with his fraternity brother and future Malaco partner Gerald "Wolf" Stephenson, observing the standoff.

Months later, the Ole Miss campus—the campus that had almost moved to Jackson at Governor Bilbo's urging but had remained in quiet, quaint Oxford—was still reeling from the aftereffects of the riots. The passions of the segregationists had been aroused, and Mississippi was soon to enter one of its most embarrassing and violent decades.

James Meredith quietly went about fulfilling the duties of a student, and Couch continued bringing in black bands to play at white fraternity houses.

Promotional poster from when Tommy Couch was a student at Ole Miss. *Malaco Records.*

After marrying Mayme Malouf—the girlfriend he'd been riding around with the night of the Oxford riot—Tommy moved to her hometown of Jackson. He was working as a pharmacist but continued to dabble in the music business.

He had gotten a taste of the potential of the Jackson market while still a student at Ole Miss. Couch had booked the Del Rays for a show after a football game at the King Edward Hotel downtown. The show turned out to be wildly popular, with a line of football fans waiting to get in the door of the King Edward. Couch made a nice $2,000 profit for himself.[430] "That was more money than I'd ever seen in my life," Couch said. "We had a whole bed of one-dollar bills that we split up."

After moving to Jackson, Couch hooked back up with his friend and fellow Pi Kappa Alpha member Wolf Stephenson. Couch and Stephenson began booking bands at the Mississippi Coliseum. His ability to book a marquee band and promote it started to pay off. In

1964, Couch decided he wanted to expand his music enterprise. He and his brother-in-law, Mitchell Malouf, bought some property on 3023 West Northside Drive with the intent of running a recording studio. The new business was given the name Malaco Records after its two co-founders, *Mal*ouf and *C*ouch.[431]

The recording side of their business grew very slowly. The company stayed in business only by booking bands and writing jingles. It also paid the bills by recording educational programs, such as Dr. Arthur Guyton's series. Guyton was a nationally known psychologist and dean of the University of Mississippi Medical Center.[432]

While happy to be running their own business, Malaco's owners still dreamed of producing a hit record, and they continued plugging away in their recording studio in search of that elusive singer or song that would put their studio on the map.

As to the studio itself, it was not exactly the venue that would attract the "already made it" singers and bands. In fact, it looked like a bait shop, so much so that at one point a sign was placed outside that read, "Also Worms and Minnows."

The front doors of the building opened directly into the studio, and more than a few times, drunks would walk by, hear the music and interrupt a recording session by wandering in, thinking that the "club" was in full swing.[433]

Malaco Records almost collapsed in 1970. Couch and Malouf had invested heavily in bringing Ike and Tina Turner to the Mississippi Coliseum in Jackson. It was a bust; Couch and Malouf lost $5,000 on the venture.[434]

Malaco was floundering, and even its passionate owners knew it. They continued to book bands and produce jingles to pay the bills, but the hit album continued to elude them. And then Jean Knight and Wardel Quezergue came to Jackson. Finally, Malaco Records had a hit. Knight's song "Mr. Big Stuff" proved to be a resounding success.[435] The song eventually reached the no. 2 spot on *Billboard*'s "Hot 100" chart.[436]

Couch, who had started his career booking black bands for white audiences, eventually redefined his label's target audience. "We make black music for black people," Couch would eventually come to say.[437]

Fifty years on, Malaco is still recording up-and-coming artists. While it continues to record mainstream R&B and blues, its bread and butter still

From left: Wolf Stephenson, Mitchell Malouf, Jerry Wexler, Tommy Couch Sr., Jerry Puckett and Ed Butler. *Malaco Records.*

Tommy Couch Sr. *Josh Foreman.*

remains soul. Malaco Records has never produced a number-one album. It's had only three Top Ten hits in fifty years, the last in the 1970s. Still, the small Jackson company that challenged giants of the industry in Memphis and New Orleans chugs along. Couch and his crew dared to compete with big-name labels such as Chess, Atlantic, Stax and T.K., all of which have gone belly up as of 2017. Malaco Records is still recording music.

<p style="text-align:center">∽∞∾</p>

When the tornado struck in 2011, Tommy Couch was in a meeting in Brandon. His partner Wolf Stephenson and his son, Tommy Couch Jr., who is the president of the company now, were in the studio. Two other employees were in the company's offices. The office building collapsed, but the two employees there had sheltered in a bathroom. The tornado lifted the roof off the studio, and heavy rain poured into the building. Neither Tommy Couch Jr. nor Stephenson were hurt. Tommy Couch Jr. immediately called his father.

"Tommy Jr. called me and said we've had a tornado and it basically blew us away," Couch Sr. said. He rushed over from Brandon but couldn't get to the Malaco complex because of a police barricade. He knew a back way into the area, though, and was able to make his way there. "It was just...where this building was, it was just blown to hell and back," Couch Sr. said.

Although fifty years of recordings had presumably been damaged or destroyed, Couch Sr. didn't give them a thought. Instead, his mind went to checking on the safety of his friends, family and employees. He found out later that his tornado-proof concrete vault had withstood its test. His records were undamaged.

After ensuring that no one had been hurt, Couch Sr.'s mind next went to starting the rebuilding process. The same day the tornado had hit, Couch Sr. and his crew were making arrangements for a new complex to be built.

"I told Tommy Jr. we need to get some people in here immediately," Couch Sr. said. "He had a friend up in the Delta that he knew who was working on catfish ponds hauling dirt or something. He called him and within three or four hours we had two big trackhoes in here just hauling stuff away. We got on it immediately."

Malaco Records had been well insured, and the rebuilding effort took a year. Today, the complex stands humming along. In July 2017, a group of musicians from Switzerland had taken over the studios. They milled around

in the hallway, just outside the studio doors, telling stories about the artists who had recorded at Malaco in the past.

Touring the complex today, one would never know that so much had been damaged a few years before. The walls are lined with oversized film posters that feature music recorded at Malaco, blown up black-and-white photos from Malaco's early days—including one massive portrait of Mississippi Fred McDowell, a cigarette dangling from his mouth, that Couch Sr. took himself—and gold and platinum records by Bob Seger, the Blues Brothers, Kanye West and many others.

Malaco Records sits in an out-of-the-way corner of Jackson, far down Northside Drive, away from the busy commercial activity of the I-55 area. Driving through the run-down, weed-choked neighborhood that leads to the complex, it seems the last place you'd find a thriving company with such a long and storied history. But there it is. It has been, and it will be.

NOTES

Part I

1. Bushnell, "Native Ceremonies and Forms of Burial," 94.
2. Ibid., 89–90.
3. Ibid., 96.
4. Ibid., 94–95.
5. Sears, "Burial Mounds on the Gulf Coastal Plain," 281.
6. Bushnell, "Native Ceremonies and Forms of Burial," 100.
7. National Park Service, "Boyd Mounds Site," Indian Mounds of Mississippi.
8. Debo, Rise and Fall of the Choctaw Republic, 39.
9. Whicker, "Tecumseh and Pushmataha," 315–31.
10. National Register of Historic Places, Inventory-Nomination Form.
11. Mississippi Department of Archives and History, Subject File, "Doak's Stand."
12. Rowland, "Mississippi, Comprising Sketches," 803–7.
13. Ibid.
14. Ibid.
15. Busbee, *Mississippi*, 76.
16. Grant, *Dispatches from Pluto*, 101.
17. Cobb, *Most Southern Place on Earth*, 326.
18. *Clarion-Ledger*, "Louis LeFleur," November 19, 1901; *Clarion-Ledger*, "Any Time Is Fine for that Vacation," May 29, 1952; *Clarion-Ledger*, "Graceful, Rugged Louis LeFleur Planted Trade on the Pearl," August 21, 1974;

Cushman, *History of the Choctaw, Chickasaw and Natchez*, 400–404; *Clarion-Ledger*, "It's a Concrete Fact," July 29, 1957.

19. Claiborne, *Mississippi*, 116.

20. Ralph and Alberta McBride's book, *A Family Makes Its Mark: The Leflores of Mississippi*, contains the definitive account of Louis LeFleur's life and establishes that LeFleur was born in Mobile; Yancy, "Louis LeFleur, Frontiersman," *Mississippi Sideboard*.

21. Mississippi Department of Archives and History, T.R. Rehm to Peggy Heard. Rehm was archivist at the Archdiocese of Mobile and responded to Heard's request for information on the LeFleau family with a detailed description of church records; LeFlore, "Last Will and Testament," 1–2.

22. *Clarion-Ledger*, "LeFleur's Bluff Undergoes Many Changes in 100 Years," October 7, 1951.

23. White, *Wild Frenchmen and Frenchified Indians*, 211–14; Gottfred, "What Voyageurs Wore."

24. Gottfred, "What Voyageurs Wore."

25. Tilghman, "LeFlores of Mississippi."

26. McBride and McBride, *Family Makes Its Mark*, 11; Yancy, "Louis LeFleur, Frontiersman," *Mississippi Sideboard*.

27. Willis, "Choctaw Images, Courtship and Marriage"; Mississippi Department of Archives and History, T.R. Rehm to Peggy Heard.

28. Mississippi Department of Archives and History, T.R. Rehm to Peggy Heard.

29. Cushman, *History of the Choctaw, Chickasaw and Natchez*, 400.

30. LeFlore, "Last Will and Testament," 1–2; Claiborne, *Mississippi*, 116.

31. *Clarion-Ledger*, "LeFleur's Bluff Located Exactly by Commissioners," March 27, 1938.

32. Guice, "Bedfellows and Bedbugs," 10–17.

33. *Clarion-Ledger*, "Jackson Progress Thrown in Contrast by History," October 21, 1936.

34. Guice, "Bedfellows and Bedbugs," 10–17.

35. McBride and McBride, *Family Makes Its Mark*, 18.

36. Millett, "Britain's 1814 Occupation."

37. Rowland, *Mississippi*, 870–71; McBride and McBride, *Family Makes Its Mark*, 19–20.

38. Tilly, "Jackson-Dinsmoor Feud," 120.

39. Ibid.

40. Ibid., 121.

41. Ibid., 118.

42. Davis, *Way through the Wilderness.*

43. Tilly, "Jackson-Dinsmoor Feud," 121.

44. Ibid.

45. Andrew Jackson to George Washington Campbell.

46. Ibid.

47. Ibid.

48. Ibid.

49. Silas Dinsmore to Andrew Jackson.

50. Thomas Langford Butler to Silas Dinsmore, January 30, 1815.

51. Ibid., February 15, 1815.

52. Tilly, "Jackson-Dinsmoor Feud," 128.

53. Thomas Jefferson to William C.C. Claiborne; Reps, "Thomas Jefferson's Checkerboard Towns," 108–14.

54. Reps, "Thomas Jefferson's Checkerboard Towns," 109–10.

55. Ibid., 109–11.

56. Rowland, *History of Mississippi*, 497–506; Rowland, *Mississippi*, 950–51.

57. Brieger, Hometown Mississippi, 172–73.

58. Hinds and Lattimore's report to the legislature is reprinted in full in Rowland, *History of Mississippi*, 16–22.

59. Van Dorn, *Jackson, Mississippi.*

60. Rowland, *History of Mississippi*, vol. 1, 950–51.

61. Lowry and McCardle, *History of Mississippi*, 617–19.

62. McCain, *Story of Jackson*, 12–13.

63. Rowland, *Mississippi*, 950.

64. McCain, *Story of Jackson*, 9.

65. Mississippi Department of Archives and History, "Act, for the Relief of Actual Settlers."

66. Hadley, "To the Speaker of the House of Representatives."

67. McCain, *Story of Jackson*, 14–15.

68. *Natchez Gazette*, letter from Walter Leake, January 1, 1823.

69. Mississippi Department of Archives and History, Land Records.

70. McCain, "View of Jackson in 1823."

71. Gallent, "Some Reminiscences of the Past."

72. Brieger, *Hometown Mississippi*, 172–73.

Part II

73. Buchanan, "Levees of Hope," 364–65.
74. Grubbs, "Pathways of Escape," 154.
75. Rothman, *Flush Times and Fever Dreams*, 218–19.
76. Ibid., 84–86, 177.
77. Germenis, "Runaway Slave Advertisements in Mississippi."
78. *New York Times*, "Census of 1860 Population-Effect on the Representation of the Free and Slave States," April 5, 1860.
79. Mangipano, "Social Geography of Interstate Escape," 142–44.
80. Grubbs, "Pathways of Escape."
81. *Southern Sun*, "$100 Reward," August 4, 1838.
82. *Vicksburg Whig*, "$50 Reward," November 6, 1834.
83. *Weekly Mississippian*, "Was Committed," August 8, 1834.
84. Ibid., "Stop the Runaway!" October 3, 1834.
85. Mangipano, "Social Geography of Interstate Escape."
86. Ibid., 135.
87. *Weekly Mississippian*, advertisements, May 31, 1833.
88. Grubbs, "Pathways of Escape."
89. Buchanan, "Levees of Hope," 363–65.
90. *Louisville Daily Courier*, "Acknowledgments," July 21, 1845.
91. *Natchez Weekly Courier*, advertisement, April 16, 1831; *Vicksburg Whig*, advertisement, November 18, 1831; *Southern Galaxy*, advertisement, November 12, 1829.
92. *Commercial Bulletin, Price-Current and Shipping List*, "Arrived," June 27, 1829; Keating, interview by Foreman.
93. Coates, *Outlaw Years*, 227. A large number of historians today denounce the legend of John Murrell, claiming that he was nothing more than an incompetent thief. His legend grew with the publication of Virgil A. Stewart's pamphlet that promoted the idea of Murrell as "the great western land pirate." William C. Davis wrote, "No greater example of the twisting of fact into fancy when linked with the violent edge of the territory could be found than that surrounding the man once called the 'Great Western Land Pirate,' John Murrell." Davis, *Way through the Wilderness*, 278. Whether Murrell and his Mystic Confederacy is historical fact or baseless paranoia is beside the point. The people of the Deep South, including the people of Hinds and Madison Counties, *believed* it to be a very real threat. They acted accordingly. The existence of his clan lived in the minds and fears of countless white southerners. Whether those fears were justified or not remains disputed.

94. Coates, *Outlaw Years*, 227–30.

95. Knight, *Conspiracy Theories in American History*, vol. 1, 174.

96. Howard, *History of Virgil A. Stewart*, 60.

97. Rothman, *Flush Times and Fever Dreams*, 218–19.

98. Howard, *History of Virgil A. Stewart*, 60.

99. Wilson, *History of the Detection, Conviction, Life and Designs*, 34.

100. Ibid.

101. Rothman, *Flush Times and Fever Dreams*, 74–75.

102. Ibid., 80.

103. Coates, *Outlaw Years*, 281.

104. Howard, *History of Virgil A. Stewart*, 225.

105. Ibid., 226.

106. Coates, *Outlaw Years*, 283.

107. Howard, *History of Virgil A. Stewart*, 230.

108. Ibid., 230–31.

109. Coates, *Outlaw Years*, 281.

110. Wilson, *History of the Detection, Conviction, Life and Designs*, 40.

111. Howard, *History of Virgil A. Stewart*, 232.

112. Ibid., 222–23.

113. Ibid., 235–37.

114. Ibid., 239.

115. Ibid.

116. Ibid., 242.

117. Ibid., 242–43.

118. Ibid., 243.

119. *The Comet*, "The Duplex Wedding," November 27, 1879.

120. *Clarion-Ledger*, June 22, 1895.

121. Mississippi Department of Archives and History, "Manships Mary."

122. *The Comet*, "Duplex Wedding."

123. *Clarion-Ledger*, January 12, 1947.

124. *The Comet*, "Duplex Wedding."

125. *Clarion-Ledger*, January 12, 1947.

126. Ibid.

127. Mississippi Department of Archives and History, letter to Charles Manship.

128. *The Comet*, "Duplex Wedding."

129. Ibid.

130. Mississippi Department of Archives and History, "Record of a Few of the Incidents and Events," *Mississippi Victorian*.

131. *New Mississippian*, December 12, 1888.

132. *Clarion-Ledger*, June 22, 1895.

133. Mississippi Department of Archives and History, "Resolutions of Respect."

134. *Clarion-Ledger*, June 22, 1895.

135. Ibid., December 23, 1903.

136. Ibid.

137. Ibid., January 12, 1947.

138. Elder, *Civil War Diary*, May 21, 1863.

139. Oakes, *Eyewitness Account*, 22.

140. Ibid., 22, n53.

141. Pillar, *Catholic Church in Mississippi*, 257.

142. Gerow, *Catholicity in Mississippi*, 257.

143. Ibid.

144. Ibid.

145. Bernard, *Story of the Sisters of Mercy in Mississippi*, 18.

146. Oakes, *Eyewitness Account*, 23.

147. Ibid.

148. Elder, *Civil War Diary*, July 9, 1863.

149. Ibid., July 14, 1863.

150. Ibid., July 16–17, 1863.

151. Ibid., July 20, 1863.

152. Ibid.

153. Ibid.

154. Ibid.

155. Ibid., July 21, 1863.

156. Ibid.

157. Ibid., July 31, 1863.

158. Gerow, *Catholicity in Mississippi*, 347.

159. Mississippi Department of Archives and History, *Clinton Riot 1875 Campaign Document*, 13–14.

160. Ibid., 1–2.

161. Testimony of Ann Hodge, *Mississippi in 1875*, 420 ff.

162. Testimony of D.C. Crawford, *Mississippi in 1875*, 429.

163. Testimony of E.B. Welborne, *Mississippi in 1875*, 492 ff.

164. Niven, "Caldwell, Charles," *African American National Biography*.

165. Mississippi Department of Archives and History, *Clinton Riot 1875 Campaign Document*, 9–10.

166. Prather, "Remembering the Clinton Massacre."

167. Testimony of Ann Hodge, *Mississippi in 1875*, 420–23.

168. Testimony of Walter A. Bracey, *Mississippi in 1875*, 360–62.

169. Testimony of John E. Estell, *Mississippi in 1875*, 318 ff.

170. Testimony of Frank Johnston, *Mississippi in 1875*, 353.

171. Testimony of William A. Montgomery, *Mississippi in 1875*, 540 ff.

172. Testimony of Walter A. Bracey, *Mississippi in 1875*, 360–62.

173. Testimony of John E. Estell, *Mississippi in 1875*, 318 ff.

174. Testimony of D.C. Crawford, *Mississippi in 1875*, 429.

175. Testimonies of Dennis McCoy and John E. Estell, *Mississippi in 1875*, 445 ff.

176. Mississippi Department of Archives and History, *Clinton Riot 1875 Campaign Document*, 8–9.

177. Testimony of Ann Margaret Caldwell, *Mississippi in 1875*, 435 ff.

178. Niven, "Caldwell, Charles," *African American National Biography*.

179. Mississippi Department of Archives and History, *Clinton Riot 1875 Campaign Document*, 6.

180. Testimony of Ann Margaret Caldwell, *Mississippi in 1875*, 435 ff.

181. Telegram from W.A. Montgomery to J.Z. George.

182. "Testimony in the Impeachment of Adelbert Ames," 93.

183. Ibid., 93–94.

184. Ibid., 88–93.

185. Ibid., 3.

186. Ibid., 3–4.

187. Ibid., 5.

188. Ibid., 6.

189. Woodward, *Strange Career of Jim Crow*, 27–29.

190. Ibid., 41–42.

191. Busbee, *Mississippi*, 153.

192. Porch, "When the Right to Vote Wasn't a Right."

193. The account here is fictional but accurately describes how yellow fever is contracted and its symptoms. Data comes from the World Health Organization website, http://www.who.int/mediacentre/factsheets/fs100/en.

194. Bloom, *Mississippi Valley's Great Yellow Fever Epidemic*, 141, 280.

195. Ibid., 108.

196. Ibid.

197. Ibid., 116.

198. Ibid.

199. Ibid., 141.

200. Bernard, *Story of the Sisters of Mercy in Mississippi*, 65.

201. Ibid., 66.

202. Oakes, *Eyewitness Account*, 55.

203. Bernard, *Story of the Sisters of Mercy in Mississippi*, 67.

204. Ibid.

205. Ibid., 69.

206. Gerow, *Catholicity in Mississippi*, 57.

207. Bernard, *Story of the Sisters of Mercy in Mississippi*, 68–69.

208. Healy, *Sisters of Mercy*, 158–60.

209. Mississippi Department of Archives and History, *Mississippi Victorian*.

Part III

210. *Times-Picayune*, "Tragedy at Jackson," March 18, 1893; Gilmore, "Gilruth v. Decell," 214–15; *Southern Reporter*, "Moore v. Decell," 681–82.

211. *Times-Democrat*, "Family Troubles," March 18, 1893.

212. *Clarion-Ledger*, "Killing of T.F. Decell," March 23, 1893.

213. The events of T.F. and Kate Decell's saga were recounted in several newspaper articles: *Clarion-Ledger*, "Killing of T.F. Decell," March 23, 1893; *Times-Picayune*, "Tragedy at Jackson," March 18, 1893; *Yazoo Herald*, "Killing of Mr. T.F. Decell," March 24, 1893; *Daily Commercial Herald*, "Killed by His Wife's Brothers," March 18, 1893. The definitive retelling seems to come from a story about the coroner's inquest, which includes witness testimony: *Times-Democrat*, "Jackson Tragedy," March 19, 1893.

214. Find a Grave, "T.F. Decell"; *Times-Democrat*, "Family Troubles."

215. *Daily Commercial Herald*, "Killed by His Wife's Brothers."

216. Hathi Trust Digital Library, Official Army Register of the Volunteer Force, Parts 1–8; National Park Service, U.S. Civil War Soldiers, 1861–65; Reid, *Ohio in the War*, 187–93.

217. Ellzey, *Images of America: Yazoo*, 47.

218. Thornton frequently bought ads in the Yazoo papers, advertising his businesses, inviting people to his town and updating readers on his life: *Yazoo Herald*, "Fine Cotton," January 10, 1879; *Yazoo Herald*, "Personal," June 20, 1890; *Yazoo Herald*, "The Thornton Barbecue," June 14, 1889; *Yazoo Herald*, "The Herald Received…," October 21, 1892; *Vicksburg Whig*, "Madison College," October 10, 1860.

219. *Times-Picayune*, "Tragedy at Jackson," March 18, 1893.

220. Ibid.

221. Measuring Worth, "Relative Values—US$."
222. Details of the forgery were recorded in multiple lawsuits that were eventually heard by the Mississippi Supreme Court. Gilmore, "Gilruth v. Decell," 214–15; *Southern Reporter*, "Moore v. Decell," 681–82.
223. Ibid.
224. *Times-Democrat*, "Family Troubles."
225. *Yazoo Herald*, "Killing of Mr. T.F. Decell."
226. *Daily Commercial Herald*, "A Thorough Investigation Terminates in the Acquittal of the Prisoners," March 19, 1893.
227. *Yazoo Herald*, "Killing of Mr. T.F. Decell."
228. "F.J. Decell," Mississippi Wills and Probate Records.
229. *Yazoo Herald*, "Thornton Burned," December 8, 1893.
230. U.S. Census Bureau, Twelfth Census of the United States; U.S. Census Bureau, Fourteenth Census of the United States.
231. *Weekly Clarion-Ledger*, "Around the City," June 6, 1895.
232. The final hours of Jackson's existence as a wet city were recorded in *Clarion-Ledger*, "Around the City," June 5, 1895.
233. *Weekly Democrat*, "Dry as Tinder," June 12, 1895.
234. *Vicksburg Evening Post*, "Jackson a Dry Town," June 6, 1895.
235. McCain, *Story of Jackson*, 14.
236. Reverend W.H. Perkins, quoted in Bailey, *Prohibition in Mississippi*, 182.
237. Bailey, *Prohibition in Mississippi*, 172–75.
238. Axley, "Drunk Again."
239. *Daily Commercial Herald*, "Twenty-Five Blind Tigers Indicted," November 11, 1893.
240. *Clarion-Ledger*, "Local News and Notes," March 1, 1888; Bailey, *Prohibition in Mississippi*, 173–74.
241. *Jackson Daily News*, "She Recalls Blind Tiger Days with Some Nostalgia," August 16, 1970.
242. *Clarion-Ledger*, "No Blind Tigers," June 8, 1895.
243. *Vicksburg Evening Post*, "A Blind Tiger Is Stirred Out at Jackson," July 25, 1895.
244. *Clarion-Ledger*, "Who Drinks the Most," April 5, 1897.
245. Ibid., "Official Proceedings," May 24, 1893; *Clarion-Ledger*, advertisement, March 7, 1892; *Clarion-Ledger*, "Around the City," May 16, 1894.
246. *Clarion-Ledger*, "Hop Joints Indicted," July 23, 1897.
247. Ibid., "Raid on Blind Tigers," July 24, 1895.
248. Ibid.

249. *Vicksburg Evening Post*, "Rankin Blind Tiger Man Shot to Death," August 22, 1904; *Clarion-Ledger*, "A Penitentiary Charge," April 29, 1902; *Clarion-Ledger*, "The Police Investigation," July 8, 1898; *Clarion-Ledger*, "A Sensational Shooting," April 14, 1902.

250. *New Mississippian*, "The Great Jackson Boycottist," August 16, 1887.

251. *Clarion-Ledger*, "An Open Letter," February 19, 1894.

252. Ibid., "The Blind Tigers," June 18, 1898.

253. *Natchez Democrat*, "Jackson Budget," May 10, 1899.

254. *Clarion-Ledger*, "Caught a Bling Tiger," January 22, 1896; *Clarion-Ledger*, "Around the City," July 25, 1895; *Clarion-Ledger*, "He Has the Proof," November 30, 1896.

255. Davis, "Attacking the 'Matchless Evil,'" 60.

256. *Vicksburg Herald*, "From Canton," August 3, 1886.

257. Bailey, *Prohibition in Mississippi*, 172–78.

258. Davis, "Attacking the 'Matchless Evil,'" 250–56.

259. Bilbo, "Inaugural Address of Gov. Theo. G. Bilbo."

260. Sansing, *Making Haste Slowly*, 73.

261. Bilbo, "Inaugural Address of Gov. Theo. G. Bilbo."

262. Sansing, *Making Haste Slowly*, 74; *Clarion-Ledger*, "Two and One Half Million Voted by Mass Meeting," February 2, 1928.

263. *Clarion-Ledger*, "Medical and Law Departments May Be Removed to Jackson," September 27, 1927; *Stone County Enterprise*, editorial, November 10, 1927.

264. *Yazoo Herald*, "Plans Are Made to Remove 'Ole Miss' to Capitol City," January 20, 1928; *Clarion-Ledger*, "The Senate Proceedings," January 19, 1928.

265. Butler, "Bilbo," 500–501.

266. Bilbo, "Inaugural Address of Gov. Theo. G. Bilbo."

267. Sansing, *Making Haste Slowly*, 72–73.

268. Butler, "Bilbo," 502–3.

269. Theodore Bilbo to "Sir."

270. O'Shea, *Public Education in Mississippi*, 202–10.

271. Ibid., 214–15.

272. O.L. Bond, "The University of Mississippi at the Crossroads," *Stone County Enterprise*, November 10, 1927.

273. *Simpson County News*, "University Removal," February 2, 1928; *Clarion-Ledger*, "Lawmakers Going to Oxford Today," February 3, 1928.

274. *Clarion-Ledger*, "Legislators Return Home from Oxford," February 5, 1928.

275. Ibid., "The House Proceedings," February 16, 1928; *Simpson County News*, "University and Printing Worry Solons," February 16, 1928.

276. *Clarion-Ledger*, "Delivery of Governor's Message Opens Legislature," January 8, 1930.

277. Sansing, *Making Haste Slowly*, 78–79.

278. Ibid., 80–84.

279. *Clarion-Ledger*, "State Medical Center with College Ok'd by Mississippi Senators," February 2, 1950.

280. Ibid.

281. Allard, "History of the Clinton Prisoner of War Camp," iv.

282. Ibid., 3–4.

283. Ibid., 18.

284. Ibid., 49–50.

285. Ibid., 33.

286. Ibid., 56.

287. Ibid., 90.

288. Ibid., 58.

289. Ibid., 76.

290. Ibid., 70.

291. Ibid., 72.

292. Ibid., 72–73.

293. Ibid., 80.

294. Ibid., 77.

295. *Clarion-Ledger*, "German POW Hangs Self in Tree Here," August 7, 1945.

296. Allard, "History of the Clinton Prisoner of War Camp," 115.

297. Ibid., 116.

298. Ibid., 101.

299. Ibid., 101–2.

300. Ibid., 121–22.

301. Ibid., 134–36.

302. Mississippi Department of Archives and History, "Dutch Fliers."

303. Ibid., *2012 Veterans Day Commemoration*.

304. Jean Culbertson, "Flying Dutchmen First Came to Jackson 25 Years Ago," *Clarion-Ledger/Jackson Daily News*, May 7, 1967, Subject File at Mississippi Department of Archives.

305. Ibid.

306. Mississippi Department of Archives and History, *Army Air Forces Historical Studies*.

307. Carl McIntire, "Remains of Dutch WWII Plane Thought to Be Found," *Clarion-Ledger*, December 20, 1981.

308. *Clarion-Ledger*, "First Dutch Baby Born During Jackson Occupation," May 12, 1953.

309. Deborah Skipper, "Dutch Airman's Connection to Jackson Comes Full Circle," *Clarion-Ledger*, May 27, 2007.

310. Ibid.

311. *Clarion-Ledger*, "A Day to Remember: Ashes of Dutch Airman Buried Among Comrades," May 29, 2007.

312. Deborah Skipper, "Dutch Airman's Connection."

313. Ibid.

314. *Clarion-Ledger*, "Day to Remember."

315. Ibid., "Lest We Forget—Jackson Holds All That Is Mortal of a Group of Brave Men," May 12, 1953.

Part IV

316. Namorato, *Catholic Church in Mississippi*, 104.

317. Brunini, *Memoirs of a Southern Bishop*, 8.

318. Namorato, *Catholic Church in Mississippi*, 106.

319. Brunini, *Memoirs of a Southern Bishop*, 35.

320. Ibid., 36.

321. Brady, "Black Monday."

322. Whitfield, *Death in the Delta*, vii.

323. Ibid., 135.

324. Brunini Diary, February 5, 1962.

325. Ibid., February 19, 1962.

326. Ibid., March 12, 1962.

327. Featherston, "Beleaguered Bill Minor."

328. Bill Minor, "Risk-Taking Bishop: Joseph Bernard Brunini," *New York Times*, December 25, 1969.

329. Ibid.

330. Best, *Seventy Septembers*, 57.

331. Brunini, Pastoral Letter.

332. Ibid., *Memoirs of a Southern Bishop*, 36.

333. Ibid.

334. Ibid.

335. Ibid.

336. Salter, *Jackson, Mississippi*, 207–23.

337. Bill Simpson, "Race Tension Here Eases Up Slightly," *Clarion-Ledger*, May 26, 1963.

338. *Lake Charles American-Press*, "No Change in Policy, Mayor Says," May 14, 1963.

339. Dittmer, *Local People*, 161–63.

340. *Salina Journal*, "Fun and Games in the South," May 29, 1963.

341. *Times Herald*, "Negro Youths Refuse Food," June 2, 1963.

342. Bill Simpson, "Police Detain Wilkins and Other Agitators Saturday," *Clarion-Ledger*, June 2, 1963.

343. Dittmer, *Local People*, 162–63.

344. *Salina Journal*, "Bomb Tossed at Negro Home," May 29, 1963.

345. *Clarion-Ledger*, "We Can Handle 100,000 Agitators," June 2, 1963.

346. *Greenwood Commonwealth*, "Thompson Says Crisis About Over," June 3, 1963.

347. Singleton, interview by Foreman and Starrett.

348. Elaine Woo, "John Doar Dies at 92; Key Justice Department Civil Rights Lawyer," *Los Angeles Times*, November 12, 2014.

349. Minor, "Remembering Freedom Summer."

350. *Clarion-Ledger*, "Funeral March Finishes in White-Led Agitation," June 16, 1963.

351. Bill Simpson, "Police Detain Wilkins."

352. Minor, interview by Till.

353. Salter, *Jackson, Mississippi*, 218–19.

354. Namorato, *Catholic Church in Mississippi*, 91.

355. James Saggus, "Negro Group Files Suit to Mix Jackson Schools," *Hattiesburg American*, March 4, 1963; *Singleton v. Jackson Municipal Separate School District*; Singleton, interview by Foreman and Starrett.

356. Singleton, interview by Foreman and Starrett.

357. Ibid.

358. Ibid.

359. Baroni, interview by Hogan.

360. Morris, "Forcing Progress."

361. Richard Harwood, "Integration Comes to Mississippi," *Washington Post*, February 15, 1970.

362. *Eddie Mitchell Tasby, et al v. Dr. Nolan Estes, et al.*

363. *Clarion-Ledger*, "NAACP to Appeal Jackson Mix Ruling," January 24, 1970.

364. Harwood, "Integration Comes to Mississippi."

365. U.S. Commission on Civil Rights, "Race and the Public Education System in Mississippi."

366. James Gilbert to Diocesan Principal.

367. Ibid.

368. Ibid.

369. Resolutions before the Principals and Diocesan School Board, December 6, 1969.

370. Barrett, "Ross Barnett at Homecoming."

371. Claude Sitton, "Negro at Mississippi U. as Barnett Yields; 3 Dead in Campus Riot, 6 Marshals Shot; Guardsmen Move in; Kennedy Makes Plea," *New York Times*.

372. Spencer, "Neighbor to an Indian Chief," 599–607.

373. The City of Jackson, "History of Jackson."

374. United States Census Bureau, "Population of the 100 Largest Urban Places: 1960."

375. *Ross Barnett Reservoir*, pamphlet.

376. Sorrels, "Pearl River Valley Reservoir Project."

377. Ibid.

378. Barnett Reservoir, Pearl River Valley Water Supply District, "About Us."

379. *New York Times*, "Transferred to Prison," June 16, 1961.

380. Sitton, "Negro at Mississippi U."

381. Claude Sitton, "200 Policemen with Clubs Ring Campus to Bar Negro," *New York Times*.

382. "Governor Barnett's Declaration to the People."

383. Silver, *Mississippi*, 97–98.

384. Ibid., 96–98.

385. Sitton, "Negro at Mississippi U."

386. *United Press International*, "Barnett Maintains UM Segregated," June 7, 1963.

387. *New York Times*, "Mississippi Board Weighs Move to Expel Meredith from School," July 10, 1963.

388. Ibid., "Ross Barnett, Segregationist, Dies; Governor of Mississippi in 1960s," November 7, 1987.

389. "Minutes of a Regular Meeting."

390. Dataset shows white and nonwhite population in Mississippi at the time of the 1960 census. National Historical Geographic Information System, Minnesota Population Center, "U.S. Geographic Summary Data and Boundary Files."

391. "Citizens of Oxford to Ross Barnett."

392. Errol Castens, "City Dedicates New EOC, Fire Station," *Oxford Citizen*, 2015.

393. Sorrels, "Pearl River Valley Reservoir Project"; "MINUTES OF A REGULAR MEETING."

394. *Greenwood Commonwealth*, "Record Floodwaters Inch Up in Jackson," April 17, 1979.

395. George Woodliff, interview by Foreman.

396. Mississippi Department of Archives and History, notes taken from "Jackson Flood, 1979."

397. *New York Times*, "Mississippi's Capital Is Flooded by River; 15,000 Leave Homes," April 16, 1979.

398. Cliff Treyens, "Weary Flood Fighters Regroup," *Clarion-Ledger*, April 17, 1979; Jack Bleich, "The Flood…What Caused the Catastrophe?" *Clarion-Ledger*, April 22, 1979.

399. Chapman, "After the 1979 Easter Flood."

400. *Clarion-Ledger*, "Cramming on Flood Insurance," April 23, 1979.

401. Joe Sterling and Cliff Treyens, "Jackson Begins Big Mop-Up," *Clarion-Ledger*, April 13, 1979.

402. *Hattiesburg American*, "Mississippians Flee Floods," via Associated Press, April 15, 1979.

403. Ibid.

404. Cliff Treyens and Joe Sterling, "Jackson Declares Flood Emergency," *Clarion-Ledger*, April 14, 1979.

405. Bob Zeller, "State Convicts Help Shore Up City Levee," *Clarion-Ledger*, April 17, 1979.

406. Bleich, "The Flood."

407. Jill Woodliff, interview by Foreman.

408. Fredrika Sherwood, "Staff Photo," *Clarion-Ledger*, April 15, 1979.

409. Judy Putnam, "Wry Jokes Help Victims to Cope with Flood Loss," *Clarion-Ledger*, April 15, 1979.

410. Hederman, *Great Flood 1979*.

411. *Greenwood Commonwealth*, "Record Floodwaters Inch Up in Jackson."

412. Erwin Ward, "Flood Photos," *Northside Sun*, April 19, 1979.

413. Hederman, *Great Flood 1979*.

414. Foreman, interview by Foreman.

415. Couch, interview by Starrett and Foreman.

416. Singleton, interview by Foreman and Starrett.

417. Chapman, "After the 1979 Easter Flood."

418. Murphy Givens, "Jackson 'River Desk' Unmanned by Expert," *Clarion-Ledger*, April 22, 1979.

419. Chapman, "After the 1979 Easter Flood."

420. Sorrels, "Pearl River Valley Reservoir Project."

421. Bleich, "The Flood"; National Weather Service Forecast Office, "San Francisco Bay Area/Monterey."

422. Ibid.

423. *New York Times*, "Mississippi's Capital Is Flooded by River."

424. National Weather Service, "Jackson, MS 1979 Pearl River Flood."

425. Ibid.

426. Couch, interview by Starrett and Foreman.

427. Bowman, *Malaco Records*, 1.

428. Couch, interview by Starrett and Foreman.

429. Bowman, *Malaco Records*, 2.

430. Ibid.

431. Ibid., 5.

432. Ibid., 14–15.

433. Ibid., 19.

434. Ibid.

435. Ibid., 19–20.

436. *Billboard*, "Jean Knight Chart History."

437. Bowman, *Malaco Records*, 1.

BIBLIOGRAPHY

Articles

Axley, Lowry. "Drunk Again." *American Speech* 4, no. 6 (1929).

Buchanan, Thomas C. "Levees of Hope." *Journal of Urban History* 30, no. 3 (2004).

Bushnell, Daniel I., Jr. "Native Ceremonies and Forms of Burial East of the Mississippi." *Smithsonian Institution Bureau of American Ethnology*, Bulletin 71 (1994).

Butler, Hilton. "Bilbo—The Two-Edged Sword." *North American Review* 232, no. 6 (December 1931).

Chapman, Stephen. "After the 1979 Easter Flood." *New Republic*, May 11, 1979.

Featherston, James. "Beleaguered Bill Minor." *Nieman Reports* (Winter 1978).

Gallent, Colonel J.M. "Some Reminiscences of the Past." *Magnolia Gazette*, June 2, 1888.

Germenis, Matthew. "Runaway Slave Advertisements in Mississippi: Violence and Dominion." *Journal of Mississippi History* 75, no. 2 (2013).

Gottfred, Angela. "What Voyageurs Wore." *Northwest Journal*. http://www.northwestjournal.ca/XVII1.htm.

Grubbs, Kevin "Pathways of Escape." *Journal of Mississippi History* 75, no. 2 (2013).

Guice, John D.W. "Bedfellows and Bedbugs: Stands on the Natchez Trace." *Southern Quarterly* 48, no. 1 (2010).

Mangipano, John. "Social Geography of Interstate Escape." *Journal of Mississippi History* 75, no. 2 (2013).

Millett, Nathaniel. "Britain's 1814 Occupation of Pensacola and America's Response: An Episode of the War of 1812 in the Southeastern Borderlands." *Florida Historical Quarterly* 84, no. 2 (2005).

Porch, Scott. "When the Right to Vote Wasn't a Right." *Daily Beast,* June 2014. http://www.thedailybeast.com/when-the-right-to-vote-wasnt-a-right.

Prather, Scott. "Remembering the Clinton Massacre." *Jackson Free Press,* September 30, 2015. http://www.jacksonfreepress.com/news/2015/sep/30/remembering-clinton-massacre.

Reps, John W. "Thomas Jefferson's Checkerboard Towns." *Journal of Architectural Historians* 20, no. 3 (1961).

Sears, William H. "Burial Mounds on the Gulf Coastal Plain." *American Antiquity* 23, no. 3 (1958).

Southern Reporter 17. "Moore v. Decell" (1895): 681–82.

Spencer, Elizabeth. "Neighbor to an Indian Chief." *Sewanee Review* 104, no. 4 (1996): 599–607. http://www.jstor.org.libproxy.unh.edu/stable/27547269.

Tilly, Bette B. "The Jackson-Dinsmoor Feud: A Paradox in Minor Key." *Journal of Mississippi History* 39 (1977).

Whicker, J. Wesley. "Tecumseh and Pushmataha." *Indiana Magazine of History* 18, no. 4 (1922): 315–31.

Willis, Loretta. "Choctaw Images, Courtship and Marriage." *A Choctaw Anthology III*. Philadelphia, MS: Choctaw Heritage Press, 1985.

Books

Bailey, Thomas Jefferson Bailey. *Prohibition in Mississippi, or Anti-Liquor Legislation from Territorial Days, with Results in the Counties*. Jackson, MS: Hederman Brothers, 1917.

Bernard, Mother M. *The Story of the Sisters of Mercy in Mississippi*. New York: P.J. Kennedy & Sons, 1931.

Best, Mary E. *Seventy Septembers*. USA: Holy Spirit Missionary Sisters, 1988.

Bloom, Khaled J. *The Mississippi Valley's Great Yellow Fever Epidemic of 1878*. Baton Rouge: Louisiana State University Press, 1993.

Bowman, Rob. Malaco Records: The Last Soul Company. Mississippi Department of Archives and History.

Brieger, James F. Hometown Mississippi. 2nd ed. Town Square Books, Mississippi Department of Archives and History.

Busbee, Westley F., Jr. *Mississippi: A History*. Wheeling, IL: Harlan Davidson Inc., 2005.

Claiborne, J.F.H. *Mississippi, as a Province, Territory and State*. Jackson, MS: Power and Barksdale, 1880.

Coates, Robert M. *The Outlaw Years*. Gretna, LA: Pelican Publishing Company, 2002.

Cobb, Charles C. *The Most Southern Place on Earth: The Mississippi Delta and the Roots of Regional Identity*. New York: Oxford University Press, 1992.

Cushman, Horatio Bardwell. *History of the Choctaw, Chickasaw and Natchez Indians*. Greenville, TX: Headlight, 1899.

Daniels, Jonathan. *The Devil's Backbone: The Story of the Natchez Trace*. Gretna, LA: Pelican Publishing Company, 1998.

Davis, William C. *A Way through the Wilderness: The Natchez Trace and the Civilization of the Southern Frontier*. New York: HarperCollins Publishers, 1995.

Debo, Angie. *The Rise and Fall of the Choctaw Republic*. Norman: University of Oklahoma Press, 1986.

Dittmer, John. *Local People: The Struggle for Civil Rights in Mississippi*. Chicago: University of Illinois Press, 1994.

Ellzey, John E. *Images of America: Yazoo*. Charleston, SC: Arcadia Publishing, 2014.

Gerow, Richard O. *Catholicity in Mississippi*. Marrero, LA: Hope Haven Press, 1939.

Gilmore, Eugene Allen. "Gilruth v. Decell." *Illustrative Cases on Partnership*. St. Paul, MN, 1913.

Grant, Richard. *Dispatches from Pluto: Lost and Found in the Mississippi Delta*. New York: Simon & Schuster, 2015.

Healy, Katherine, ed. *Sisters of Mercy*. Yahweh, NJ: Palest Press, 1992.

Hederman, T.M., ed. *The Great Flood 1979*. Jackson, MS: Hederman Brothers, 1979.

Howard, H.R. *The History of Virgil A. Stewart*. Spartanburg, SC: Reprint Company, Publishers, 1976.

Knight, Peter. *Conspiracy Theories in American History*. Vol. 1. Burbank, CA: ABC CLIO, 2003.

Lowry, Robert, and William H. McCardle. *A History of Mississippi: From the Discovery of the Great River by Hernando DeSoto, Including the Earliest Settlement Made by the French Under Iberville, to the Death of Jefferson Davis*. Jackson, MS: R.H. Henry & Company, 1891. Reprint, 1978.

McBride, Ralph Folsom, and Alberta Patrick McBride. *A Family Makes Its Mark: The Leflores of Mississippi.* Jacksonville, FL: McBride, 1976.

McCain, William D. *The Story of Jackson: A History of the Capital of Mississippi, 1821–1951.* Jackson, MS: Hyer Publishing Company, 1953.

Namorato, Michael. *The Catholic Church in Mississippi, 1911–1984.* West Port, CN: Greenwood Press, 1998.

Oakes, Sister Mary Paulinus Oakes, ed. *An Eyewitness Account: Angels of Mercy: A Primary Source by Sister Ignatius Sumner of the Civil War & Yellow Fever.* Baltimore, MD: Daniel L. Medinger, 1998.

O'Shea, Michael V. *Public Education in Mississippi: Report of a Study of the Public Education.* Jackson, MS: Jackson Printing Company, 1925.

Pillar, James. *The Catholic Church in Mississippi, 1837–1865.* New Orleans, LA: Hauser Press, 1964.

Reid, Whitelaw. *Ohio in the War: Her Statesmen, Her Generals, and Soldiers.* Vol. 1. Cincinnati, OH: Moore, Wilstach & Baldwin, 1868.

Rothman, Joshua D. *Flush Times and Fever Dreams.* Athens: University of Georgia Press, 2012. Accessed via ProQuest Ebook Central.

Rowland, Dunbar. *History of Mississippi, Heart of the South.* Mississippi: S.J. Clarke, 1925.

———. *Mississippi.* Atlanta, GA: Southern Historical Publishing Association, 1907.

———. "Mississippi, Comprising Sketches of Counties, Towns, Events, Institutions, and Persons, Arranged in Cyclopedic Form." Vol. 2. Edited by Dunbar Rowland, Southern Historical Association, 1916, 803–7. Subject File "Doak's Stand," Mississippi Department of Archives and History.

Salter, John R., Jr. *Jackson, Mississippi: An American Chronicle of Struggle and Schism.* Hicksville, NY: Exposition Press, 1979.

Sansing, David G. *Making Haste Slowly: The Troubled History of Higher Education in Mississippi.* Jackson: University Press of Mississippi, 2004.

Silver, James. *Mississippi: The Closed Society.* New York: Harcourt, Brace & World, 1964.

White, Sophie. *Wild Frenchmen and Frenchified Indians: Material Culture and Race in Colonial Louisiana.* Philadelphia: University of Pennsylvania Press, 2013.

Whitfield, Stephen J. *A Death in the Delta: The Story of Emmett Till.* Baltimore, MD: John Hopkins University, 1988.

Wilson, Augustus Q. *A History of the Detection, Conviction, Life and Designs of John A. Murel, the Great Western Land Pirate; Together with His System of Villainy, and Plan of Exciting a Negro Rebellion. Also, a Catalogue of the Names of Four Hundred and Fifty-Five of His Mystic Clan Fellows and Followers, and a Statement of Their*

Efforts for the Destruction of Virgil A. Stewart, the Young Man Who Detected Him. To Which Is Added a Biographical Sketch of V.A. Stewart. Cincinnati, OH, 1835. Accessed via http://hdl.handle.net/2027/yale.39002009726325.

Woodward, C. Vann. *The Strange Career of Jim Crow.* Commemorative Edition. New York: Oxford University Press, 2002.

Interviews and Speeches

Baroni, Marge. Interview by Hogan, Peter E. Tape recording. Natchez, Mississippi, February 11, 1977.

Bilbo, Theodore G. "Inaugural Address of Gov. Theo. G. Bilbo, Delivered Before the Senate and House of Representatives of the State of Mississippi. Jan. 17, 1928." McCain Library, University of Southern Mississippi.

Brady, Tom. "Black Monday." Speech to the Indianola Citizens' Council. Indianola, Mississippi, October 28, 1954.

Couch, Tommy, Sr. Interview by Ryan Starrett and Josh Foreman, July 13, 2017.

Foreman, Keith. Interview by Josh Foreman, August 14, 2017.

"Governor Barnett's Declaration to the People of Mississippi." Broadcast Via TV and radio on September 13, 1962. John F. Kennedy Presidential Museum and Library. http://microsites.jfklibrary.org/olemiss/controversy/doc2.html.

Keating, James. Interview by Josh Foreman. Bay St. Louis, Mississippi, June 21, 2017.

Minor, Bill. Interview by Morgan Till. *PBS News Hour,* March 28, 2017.

———. "Remembering Freedom Summer." Lecture, St. Richard's Catholic Church, Jackson, Mississippi, July 20, 2014.

Singleton, Derek. Interview by Josh Foreman and Ryan Starrett, June 15, 2017.

Woodliff, George. Interview by Josh Foreman, August 1, 2017.

Woodliff, Jill. Interview by Josh Foreman, August 1, 2017.

Manuscripts and Collection Files

Andrew Jackson to George Washington Campbell, October 15, 1812. Letter, from Correspondence of Andrew Jackson. Edited by John Spencer Bassett. Library of Congress. http://cdn.loc.gov/service/mss/maj/01010/01010_0104_0112.pdf.

Barrett, Russell, photographer. "Ross Barnett at Homecoming" (1962). Russell H. Barrett Collection, Special Collections, University of Mississippi Libraries.

Brunini, Joseph. *Memoirs of a Southern Bishop*. Original in Diocese of Jackson Archives, Jackson, Mississippi.

Brunini Diary. Original in Diocese of Jackson Archives, Jackson, Mississippi.

"Citizens of Oxford to Ross Barnett, Walter Sillers, and Homer S. Samuels, 27 September 1962." Western Union Telegram Collection, Archives and Special Collections, J.D. Williams Library, University of Mississippi.

Eddie Mitchell Tasby, et al v. Dr. Nolan Estes, et al. Memorandum opinion, U.S. District Court, Northern District of Texas, July 16, 1971.

Elder, Bishop William Henry. *Civil War Diary (1862–1865)*. Archives of the Diocese of Jackson, 237 East Amite Street, Jackson, Mississippi. http://gwdspace.wrlc.org:8180/xmlui/handle/38989/c016t1g8x.

"F.J. Decell." Mississippi Wills and Probate Records, 1780–1982. https://search.ancestry.com/cgi-bin/sse.dll?db=USProbateMS&gss=sfs28_ms_db&new=1&rank=1&msT=1&gsfn=t.f.&gsfn_x=NP_NN&gsln=decell&gsln_x=NP_NN_NS&MSAV=1&uidh=eo5.

Hadley, T.B.J. "To the Speaker of the House of Representatives." February 3, 1830. Transcribed and filed at MDAH.

James Gilbert to Diocesan Principal, November 21, 1969. Letter, original in Diocese of Jackson Archives, Jackson, Mississippi.

Joseph Brunini, January 2, 1970. Pastoral Letter, original in Diocese of Jackson Archives, Jackson, Mississippi.

LeFlore, Louis. "Last Will and Testament." Holmes County, Mississippi Records, Book No. 1.

McCain, William D. "A View of Jackson in 1823." Unpublished, August 2, 1950. Mississippi Department of Archives and History.

"Minutes of a Regular Meeting of the of Directors of the Pearl River Valley Water Supply District, Held 10:00 A.M., Friday, May 10, 1963 in the Offices of the District, 1141 Deposit Guaranty Building, Jackson, Mississippi." Transcript. Pearl River Valley Water Supply District, 1963.

Mississippi Department of Archives and History. *An Act, for the Relief of Actual Settlers in the Town of Jackson*. Mississippi legislature, January 23, 1824. Transcribed and filed at MDAH.

———. *Army Air Forces Historical Studies No. 64: Training of Foreign Nationals by the AAF 1939–1945*. Subject File.

———. *The Clinton Riot 1875 Campaign Document, No. 2.* Published and distributed by the Democratic-Conservative Executive Committee of 1875.

———. "Dutch Fliers: Netherlands Flying School." Subject File.

———. "Jackson Flood, 1979." Photo collection by James Whiddon.

———. Land Records. Subject File.

———. Letter to Charles Manship, August 4, 1864. Charles H. Manship Folder.

———. "Manships Mary: Weddings in the Nineteenth Century." Charles H. Manship Folder.

———. "Record of a Few of the Incidents and Events in the Life of C.H. Manship Dedicated to His Children." http://www.mdah.ms.gov/mississippivictorian/category/manship/page/12.

———. "Resolutions of Respect." Adopted by the Trustees of the Institute for the Blind, June 22, 1895. Charles H. Manship Folder.

———. Subject File, "Doak's Stand."

———. T.R. Rehm to Peggy Heard, March 23, 1989. Letter, Louis LeFleur Subject File.

———. *2012 Veterans Day Commemoration: The Royal Netherlands Military Flying School.* Brochure Subject File.

Mississippi in 1875. Report of the Select Committee to Inquire into the Mississippi Election of 1875, with the Testimony and Documentary Evidence. In Two Volumes. Vol. 1. Washington, D.C.: Government Printing Office, 1876. https://books.google.com/books?id=ULcTAAAAYAAJ&printsec=frontcover&source=gbs_ge_summary_r&cad=0#v=onepage&q&f=false.

National Register of Historic Places. Inventory-Nomination Form. Subject File, Mississippi Department of Archives and History.

Resolutions before the Principals and Diocesan School Board on December 6, 1969. Original in Diocese of Jackson Archives, Jackson, Mississippi.

Ross Barnett Reservoir. Pamphlet, Pearl River Valley Water Supply District, 1974.

Silas Dinsmore to Andrew Jackson, January 27, 1815. Letter, from Correspondence of Andrew Jackson. Edited by John Spencer Bassett. Library of Congress. http://www.loc.gov/resource/maj.01031_0020_0022.

Singleton v. Jackson Municipal Separate School District. 348 F.2d 729 (Fifth Circuit, 1965).

Telegram from W.A. Montgomery to J.Z. George, October 9, 1875. *Testimony in the Impeachment of Adelbert Ames Governor of Miss.* Jackson, MS: Power and Barksdale, State Printers, 1877.

Testimony in the Impeachment of Adelbert Ames Governor of Miss. Jackson, MS: Power and Barksdale, State Printers, 1877.

Theodore Bilbo to "Sir," undated. Letter, filed at the University of Southern Mississippi, Bilbo Papers Collection, 1910–47.

Thomas Jefferson to William C.C. Claiborne, July 17, 1804. Letter, National Archives, "Founders Online." https://founders.archives.gov/documents/Jefferson/99-01-02-0089.

Thomas Langford Butler to Silas Dinsmore, February 15, 1815. Letter, from Correspondence of Andrew Jackson. Edited by John Spencer Bassett. Library of Congress. https://www.loc.gov/resource/maj.01032_0236_0237/?sp=1.

Thomas Langford Butler to Silas Dinsmore, January 30, 1815. Letter, from Correspondence of Andrew Jackson. Edited by John Spencer Bassett. Library of Congress. https://cdn.loc.gov/service/mss/maj/01031/01031_0059_0060.pdf.

U.S. Census Bureau. Fourteenth Census of the United States, 1920.

———. Twelfth Census of the United States, 1900.

U.S. Commission on Civil Rights. "Race and the Public Education System in Mississippi." In *The Mississippi Delta Report.* Vol. 7. *Racial and Ethnic Tensions in American Communities: Poverty, Inequality, and Discrimination.* N.p., 2001.

Van Dorn, Peter. *Jackson, Mississippi.* Map, April 28, 1822. Accessed through the Mississippi Department of Archives and History.

Newspapers

Clarion-Ledger.
The Comet.
Commercial Bulletin, Price-Current and Shipping List.
Daily Commercial Herald.
Greenwood Commonwealth.
Hattiesburg American.
Jackson Daily News.
Lake Charles American-Press.
Los Angeles Times.
Louisville Daily Courier.
Natchez Democrat.
Natchez Gazette.
Natchez Weekly Courier.

New Mississippian.
New York Times.
Northside Sun.
Oxford Citizen.
Salina Journal.
Simpson County News.
Southern Galaxy.
Southern Reporter.
Stone County Enterprise.
Times-Democrat.
Times Herald.
Times-Picayune.
United Press International.
Vicksburg Evening Post.
Vicksburg Herald.
Vicksburg Whig
Washington Post.
Weekly Clarion-Ledger.
Weekly Democrat.
Weekly Mississippian.
Yazoo Herald.

Theses and Dissertations

Allard, Michael A. "A History of the Clinton Prisoner of War Camp, 1942–1946." Master's thesis, Mississippi College, 1994.

Davis, William Graham. "Attacking the 'Matchless Evil': Temperance and Prohibition in Mississippi, 1817–1908." PhD diss., Mississippi State University, 1975.

Morris, Wade H. "Forcing Progress: The Struggle to Integrate Southern Episcopal Schools." Master's thesis, Georgetown University, 2009.

Sorrels, James. "The Pearl River Valley Reservoir Project." Master's thesis, University of Mississippi, 1962.

Tilghman, Gene. "The LeFlores of Mississippi." Master's thesis, Mississippi State University, 1963.

Websites

Ancestry.com.

Barnett Reservoir, Pearl River Valley Water Supply District. "About Us." http://www.therez.ms.gov/Pages/About.aspx.

Billboard. "Jean Knight Chart History." http://www.billboard.com/artist/304341/jean-knight/chart.

The City of Jackson, Mississippi. "History of Jackson." Internet Archive Wayback Machine. https://web.archive.org/web/20100510192414/http://www.jacksonms.gov/visitors/history.

Find a Grave. "T.F. DeCell." www.findagrave.com/cgi-bin/fg.cgi?page=gr&GRid=38115218.

Hathi Trust Digital Library. Official Army Register of the Volunteer Force of the United States Army, 1861–65, Parts 1–8. https://catalog.hathitrust.org/Record/008591708.

Measuring Worth. "Relative Values—US$." www.measuringworth.com/uscompare/relativevalue.php.

Mississippi Department of Archives and History. *Mississippi Victorian* (blog). http://www.mdah.ms.gov/mississippivictorian/page/11.

National Historical Geographic Information System, Minnesota Population Center. "U.S. Geographic Summary Data and Boundary Files." http://doi.org/10.18128/D050.V11.0.

National Park Service. "Boyd Mounds Site." Indian Mounds of Mississippi: A National Register of Historic Places Travel Itinerary. https://www.nps.gov/nr/travel/mounds/boy.htm.

———. U.S. Civil War Soldiers, 1861–1865. https://www.nps.gov/civilwar/search-soldiers.htm.

National Weather Service. "Jackson, MS 1979 Pearl River Flood." http://w2.weather.gov/jan/1979_04_17_easter_flood_excerpts.

National Weather Service Forecast Office. "San Francisco Bay Area/Monterey." http://www.wrh.noaa.gov/climate/yeardisp.php?wfo=mtr&stn=KSFO&submit=Yearly+Cha.

Niven, Steven J. "Caldwell, Charles." *African American National Biography.* Edited by Ed. Henry Louis Gates Jr. and Evelyn Brooks Higginbotham. Oxford African American Studies Center. http://www.oxfordaasc.com/article/opr/t0001/e2176.

United States Census Bureau. "Population of the 100 Largest Urban Places: 1960." https://www.census.gov/population/www/documentation/twps0027/tab19.txt.

World Health Organization. "Yellow Fever." http://www.who.int/mediacentre/factsheets/fs100/en.

Yancy, Jesse. "Louis LeFleur, Frontiersman." *Mississippi Sideboard* (blog), March 18, 2017. https://jesseyancy.com/louis-lefleur-frontiersman.

INDEX

ABOUT THE AUTHORS

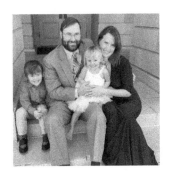

Ryan Starrett was birthed and reared in Jackson, Mississippi. After receiving degrees from the University of Dallas, Adams State University and Spring Hill College, as well as spending a ten-year hiatus in Texas, he has returned home to continue his teaching career. He lives in Madison with his wife, Jackie, and two children, Joseph Padraic and Penelope Rose O.

Josh Foreman was born and raised in the Jackson metro area. He is a sixth-generation Mississippian and an eleventh-generation southerner. He lived, taught and wrote in South Korea from 2005 to 2014. He holds degrees from Mississippi State University and the University of New Hampshire. He lives in Bay St. Louis, Mississippi, with his wife, Melissa, and his two children, Keeland and Genevieve.

CPSIA information can be obtained
at www.ICGtesting.com
Printed in the USA
BVHW04*1437300718
523024BV00012B/282/P